Contents

Introduction

This book follows on from the previous West Midland book as a study of waterways infrastructure, but in this case it is concerned specifically with the East Midlands. Navigations in this part of the country were river-orientated, suited to barge trade rather than narrowboats, but narrowboats did later extend their range into this area once a horse towing path had been constructed. Canals connected with the canalised river systems, which in turn linked with tidal waterways to the east coast.

A key navigation to this area was the Trent, which was navigable for craft following the tide as far as Newark and was deep enough for barges to reach Wilne Ferry near Derby. Such barges were locally known as Trent Boats. As more associated navigations were completed, so the range of the Trent Boat increased. Locks on the Upper Trent enabled boats to reach Burton on Trent during the early years of the eighteenth century, while the Derwent was also made navigable as far as Derby a few years later.

The Soar was a difficult river to adapt for navigation purposes. Regular floods and established weirs for the millers provided several handicaps to the navigation makers, yet parts of the Soar were made navigable. This was done at first to Loughborough through the provision of locks to bypass the millers' weirs, and then by the making of the Erewash Canal to the coal mines at Ilkeston and further north. The Soar and Erewash were worked together as a single navigation, with a short section of the Trent serving to them.

Navigation of the Trent was handicapped by shoal and shallow sections. From 1783 improvements were made to the navigation between Wilne and Gainsborough, firstly by providing a towing path and later through the making of weirs, and secondly by the Act of 1794, under which four barge locks were put in place to raise levels on the parts handicapped by shallow sections downstream as far as Holme. Such work corresponded with the period known as 'Canal Mania', when projects included the making of the Derby, Grantham, Leicester, Nottingham and Wreak navigations.

At start of the nineteenth century, a complex network of waterways had developed that served the growing needs of industry and provided the essential framework for further waterways expansion.

EAST MIDLAND CANALS

Soar, Trent, Derby, Leicester & Nottingham

THROUGH TIME

Ray Shill

AMBERLEY PUBLISHING

First published 2013

Amberley Publishing
The Hill, Stroud, Gloucestershire, GL5 4EP
www.amberley-books.com

Copyright © Ray Shill, 2013

The right of Ray Shill to be identified as the
Author of this work has been asserted in accordance with
the Copyrights, Designs and Patents Act 1988.

ISBN 978 1 4456 1149 5 (print)
ISBN 978 1 4456 1173 0 (ebook)

British Library Cataloguing in Publication Data.
A catalogue record for this book is available from the
British Library.

Typesetting by Amberley Publishing.
Printed in Great Britain.

chapter one

River Navigations

Nene, Soar, Trent

Some British rivers were deep enough for vessels to travel upstream, aided by the tide or deeper freshwater levels upriver. Around the coast the power of the tide was used to advantage by the coasting trade, and associated with this activity grew a separate trade with craft venturing inland as far as the levels permitted.

For the East Midlands, the Trent became a major navigation highway. Tidal waters reached Gainsborough and Newark. Further north water levels varied as bends in the navigation and shoals provided obstacles to boat movement, although shallow-draft barge traffic, craft known as Trent Boats, ventured upstream to Nottingham and beyond to Wilne Ferry. The medieval Trent Bridge at Nottingham was a barrier to the passage of boats but some channels were wide enough between the piers for boats to pass and continue upstream to Wilne, where the Manchester to London Road crossed at the ferry.

During the eighteenth century, a bridge over the river was made at Wilne, which became known as Cavendish Bridge. This bridge was a short distance downstream from the ferry crossing. The Upper Trent Navigation from Wilne to Burton on Trent was also established under an Act of 1699, although some ten years would elapse before the locks would be completed. There were two locks: one at Kings Mill, near Castle Donnington, and another at Burton Forge; boats were able to pass the weirs at these places.

Traffic on the Upper Trent Navigation declined during the early years of the nineteenth century, despite a junction having been made with the Derby Canal at Swarkestone. Traffic was also exchanged at a wharf near Weston, where the Trent & Mersey Canal came close to the Trent. A temporary trans-shipment wharf had been created prior to the completion of the Trent & Mersey Canal to Shardlow. Later in the century, the wharf transferred gypsum for carriage to Kings Mill, the lock there having long been disused. It appears a boat, or boats, were used for this trade on a section of the Upper Trent Navigation, and such craft may also have travelled to other destinations along the Trent, including Swarkestone.

The Nene, Ouse, Witham and Welland began as tidal rivers with links to the Wash. Their improvement was associated both with navigation and land drainage, though the emphasis was often placed on the latter. In their journeys westwards these navigations also reached the borders of the East Midlands. Navigation was also aided by the making of artificial cuts, single-barrier staunches and the upper- and lower-gated pound lock.

The Nene (or Nine) Navigation from Peterborough climbed through a series of locks that bypassed the millers' weirs. The navigation progressed steadily westward as a result of various Acts. The final part, from Thrapston as far as Northampton, was completed in 1761. The Witham was a tidal navigation from Boston to Lincoln, where it joined the Fossdyke Canal. This navigation had been cut by the Romans to link the Witham and Trent but had fallen into disuse, only to be made navigable again during the eighteenth century. A tributary of the Witham, the

Slea was made navigable through the provision of locks that enabled boats to reach Sleaford. Another branch of the Witham was the Horncastle Canal.

Parts of the Welland were made navigable upstream to Stamford through the provision of locks. The River Glen that joined the Welland was also partly adapted for navigation, yet no connections were made with the waterways in the East Midlands, despite further proposed schemes to link Stamford with Oakham, and a link between the Welland and Nene (1809). Neither of these schemes proceeded, and just two East Midland–Fenland links remained – the Nene and the Witham.

The making of the Trent & Mersey Canal, which joined the Trent near the mouth of the Derwent, encouraged further improvements to the navigation of the river and led to the formation of the Trent Navigation Company. Their first task was to gain parliamentary powers to make a long-distance towpath for horses from Derwent Mouth to Gainsborough. From 1794 the Trent Navigation Company made further improvements by building locks and weirs to raise water levels and improve navigation between Wilne and Nottingham. Navigation on the Soar was also improved, with locks that enabled craft to reach Leicester and forge links with new canals there, while locks on the Wreak made it possible for boats to go to Melton Mowbray.

Upper Trent Navigation, Kings Mill Lock Chamber and Burton Wharf
Kings Mill was one of two locks that made navigation to Burton by Trent Barges possible. Traffic through this lock is believed to have ceased early in the nineteenth century, although an accurate date has yet to be determined. Little remains of Kings Mill Lock in the 1960s view (*above*). There was a group of wharves used by boats that came up the Upper Trent. The main wharf (*below*) was located along the riverbank north of the corn market. *RCHS Hugh Compton Collection, photographer Charles Hadfield 65758; Burton Library.*

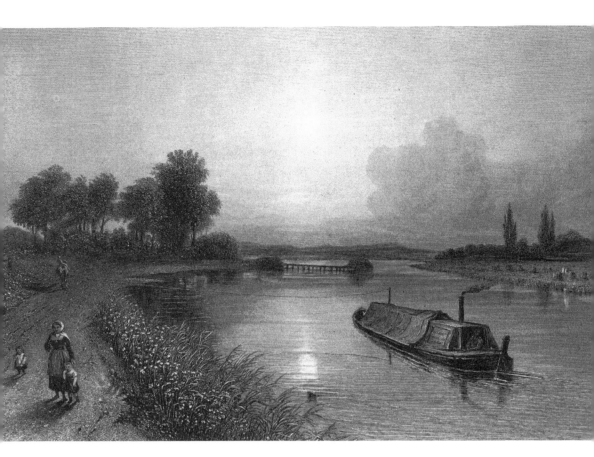

River Trent, Horse-drawn Narrowboat and the Towing Path

The Trent Navigation made arrangements with riverside landowners for a towpath along the river. Such provisions were of benefit to the barge owners, but also enabled narrowboats to travel to places that had been hitherto inaccessible. Destinations served by the Erewash, Nottingham, Loughborough and Leicester Canals all became part of an enlarged network for the narrowboat. Nottingham benefited in particular, as long-distance merchandise carriers using flyboats could serve the town. *RCHS Collection 40747.*

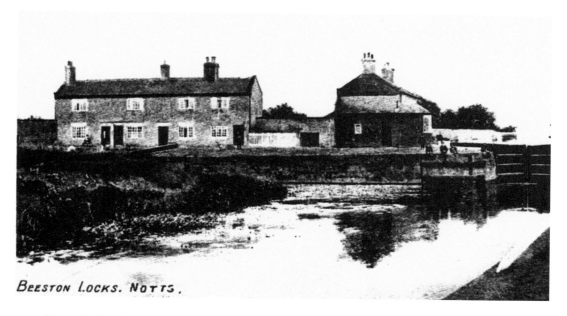

BEESTON LOCKS. NOTTS.

Trent Navigation, Beeston and Sawley Locks

The provision of locks by the Trent Navigation Company (1794) improved the navigation between Shardlow and Nottingham. At Beeston (*above*) a barge canal was constructed to link up with the Nottingham Canal at Lenton. For those craft wishing to avoid the tolls into Nottingham, or for journeys short of Nottingham, a second lock was provided to enable craft to bypass the weir and return to the Trent. In this view, the right-hand lock served barges and narrowboats passing between the Beeston Cut and the Trent. The left-hand lock enabled craft to rejoin the Trent below the weir. The lock buildings at Sawley (*below*) were placed alongside the original lock, completed under the 1794 scheme. At first the attendant lock keeper looked after one set of locks, but later this establishment was increased to a pair of locks side by side. *RCHS Postcard Collection 98024; Ray Shill.*

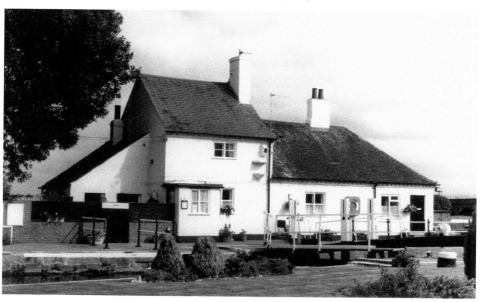

Above: River Trent, Fiskerton
The old wharf at Fiskerton has been improved and updated over the lengthy period of the navigation. *Ray Shill.*

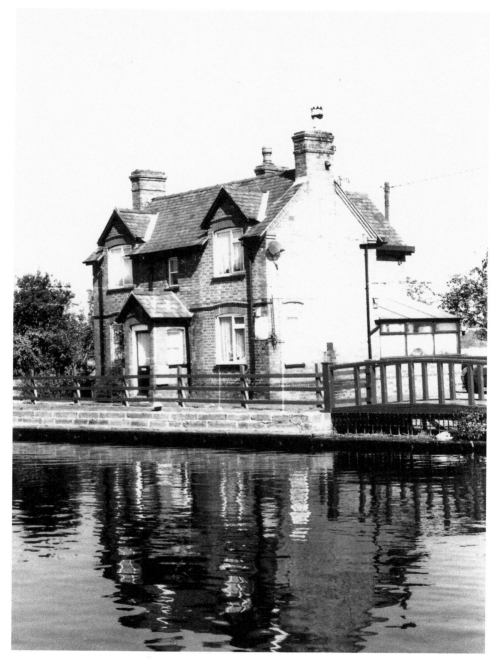

Above and Opposite Below: Soar Navigation, Canal House, Loughborough

Above, much of the Soar between the Trent and Loughborough comprised river navigations complete with lock cuts that bypassed the weirs. At Loughborough there was a length of canal that terminated at a basin, which was briefly also the trans-shipment point of the tramway link to the Charnwood Forest Canal. Opposite bottom, the final lock on the Soar Navigation from the Trent to Loughborough was placed on the Loughborough Canal. *Ray Shill*.

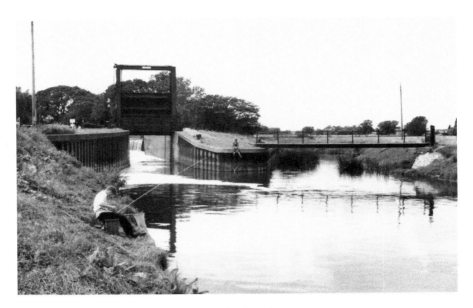

River Nene, Alwatton Lock, and Wansford Lock, 1959

The Nene was made navigable from Peterborough to Northampton with locks at the mill weirs. A feature of the Nene Lock was the lower guillotine gate. Nene locks have been altered and improved since the 1950s, but Wansford Lock was still in its unaltered condition when photographed by the canal historian Charles Hadfield. *RCHS Hugh Compton Collection, photographer L. A. Edwards 65228, photographer Charles Hadfield 65222.*

Wreak Navigation, Eye Kettleby Lock and Bridge, 1966, and Holby
RCHS Hugh Compton Collection, photographer Peter Stevenson 65174; RCHS Print Collection 40432.

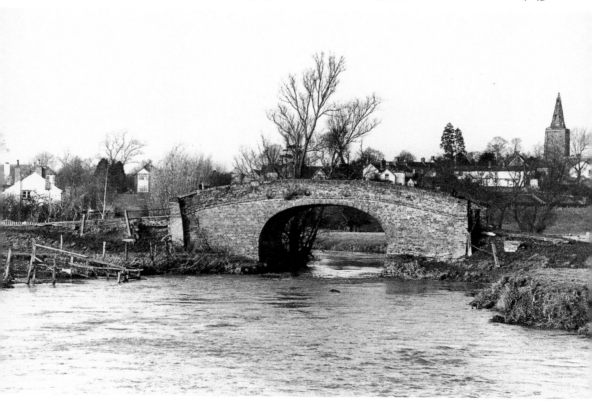

Early Canals in the East Midlands

Bond End, Chesterfield, Oxford & Trent & Mersey

The first canals in this region were the Bond End Canal at Burton, the Chesterfield and the Grand Trunk (Trent & Mersey Canal).

The Bond End Canal was constructed privately through land principally belonging to the Paget family. It linked the Upper Trent Navigation with Shobnall on the banks of the Trent & Mersey Canal. Construction of both waterways in Burton was a contemporary affair, with the Bond End Canal under construction towards Shobnall at the same time that contractors were making the canal from Wichnor to Horninglow.

Much of the Trent & Mersey route is discussed in the West Midlands book, but from Fradley this waterway headed east and included a short river section on the Trent between Alrewas and Wichnor. From Wichnor the Trent went on towards Burton. The navigation descended through Wichnor Lock onto a straight canal course for Shobnall and Horninglow.

From Horninglow the Trent & Mersey was made wide enough for Trent Boats and all locks down to the Trent at Derwent Mouth were made barge width, providing a canal alternative to the Upper Trent Navigation for trade to and from the Trent for Burton.

The Chesterfield was a waterway that crossed the northern perimeter for Nottinghamshire and Derbyshire to terminate at Chesterfield and serve the iron and coal industry there. This canal had locks wide enough for barge traffic as far as Retford. From there the canal crossed the Idle Valley by a narrow canal that climbed up to Worksop and the summit at Norwood before descending again to Staveley and then climbing once more to the terminus at Chesterfield.

Making the Oxford Canal was a slow process. Construction started on the outskirts of Coventry in the West Midlands. The canal works steadily progressed eastwards towards Rugby and Braunston before turning west again, and then progressed south to Banbury and finally Oxford, where a junction was made with the Thames in 1790. Braunston subsequently became a canal junction when work on the Grand Junction Canal began.

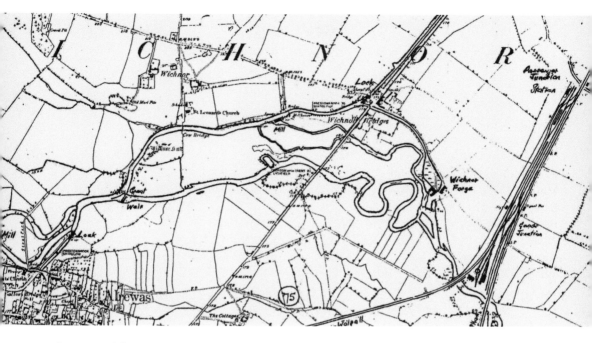

Alrewas–Wichnor Section of the Trent & Mersey Canal

The late Peter Stevenson produced this map of the Trent & Mersey Canal for a guided walk along this section of the canal in 1984. He highlighted parts of the Ordnance Survey of 1884 to show the important features. In making the Trent & Mersey at this spot, James Brindley adopted the plan of a lock at Alrewas where narrowboats descended to or ascended from the River Trent. Brindley then used a portion of the Trent to the Great Weir as well as portions of the channels that fed water to Wichnor Mill, which in Brindley's time had been converted from a corn mill to an ironworks. Between 1763 and 1765 an additional channel, or canal, had been cut to the north. This work resulted in a new bridge for the turnpike to cross and provided the necessary water supply for the rolling mill. Brindley appears to have used part of this channel to access Wichnor Lock. *Ray Shill.*

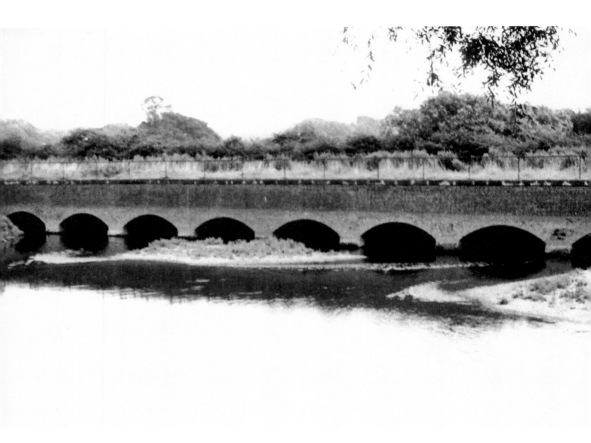

Above: Trent & Mersey Canal, Dove Aqueduct
Brindley's aqueduct over the Dove, east of Burton on Trent, is a long structure of nine arches, which was completed as the waterway construction moved onto to Shardlow. It was a substantial structure, and one that was made wide enough for Trent Boats to travel up to Horninglow. *RCHS Kenneth Gardiner Collection 78151.*

Opposite: Trent & Mersey Canal, Horninglow Warehouses and Wharf
Warehouses that spanned the canal were rare, but the eighteenth-century Horninglow Warehouse was strategically placed for the Burton brewery trade. Parts of this structure were completed soon after canal construction reached the spot (1771). It was in direct competition with the Burton Boat Company's own operation, which opened a barge canal from Bond End to Shobnall where their new warehouse was located. Horninglow was placed on a main road out of Burton and fortunately south of the turnpike gate, which effectively led to cheaper transport charges for wagons serving the town. Horninglow was also the limit for the barges that came up the canal from the Trent at Shardlow. Craft travelling from Horninglow towards Great Haywood and Potteries were narrowboats only. The Trent Barges that travelled eastward onto the Trent served Nottingham and Gainsborough. *RCHS Hugh Compton Collection, photographer Peter Stevenson 65802, 65812.*

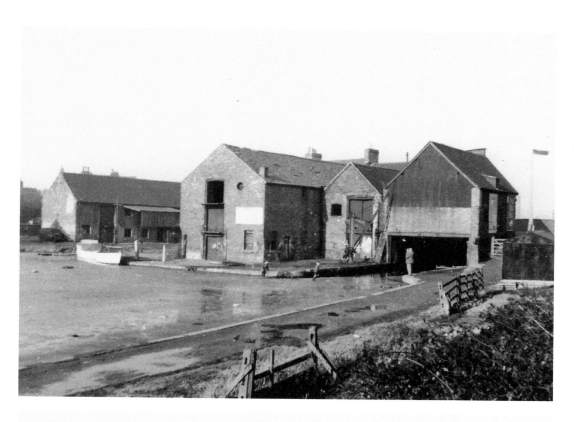

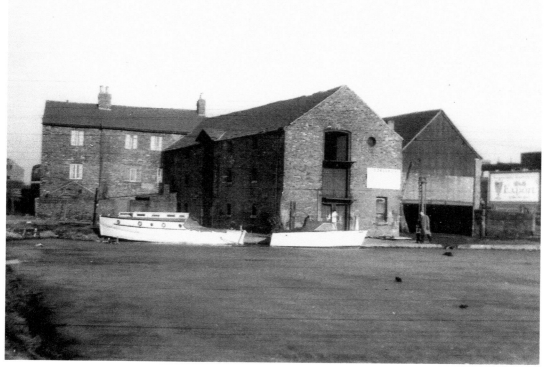

Bond End Canal, Burton Boat Company, Shobnall Basin and the Public House at Shobnall
The Bond End Canal was connected by a narrow lock to the Trent & Mersey Canal at Shobnall. When the canal was closed in the 1870s the part at Shobnall was altered (1874/75) into a railway interchange basin (*above*) for the Midland Railway Bond End Branch, which was built along the route of the former canal. The buildings erected at the entrance to Shobnall Basin and former link to Bond End Canal, were associated with the Bond End Canal, but were later converted into a canalside public house. *RCHS Hugh Compton Collection, photographer Peter Stevenson 65805, 65803.*

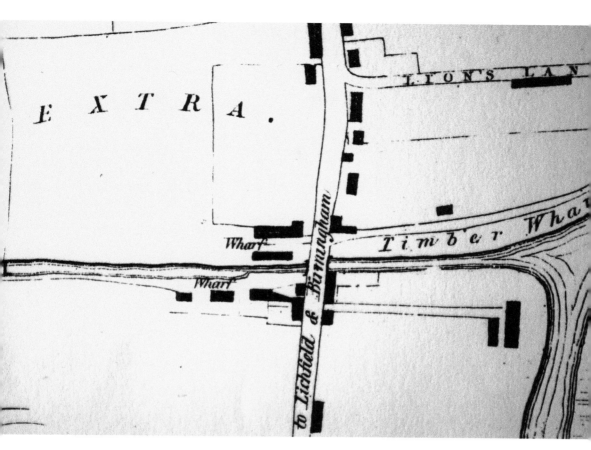

Bond End Canal, Bond End Lock

The Bond End remained a private waterway but was still used by narrowboats. After passing Shobnall Lock they travelled down to the brewery wharves and merchandise depots beside the Bond End Lock, Lichfield Road. Craft also went through this lock to reach wharves alongside the Trent. Grand Junction Canal Carrying Company craft continued to deliver and collect from the river wharf as late as the 1860s. *Burton Library.*

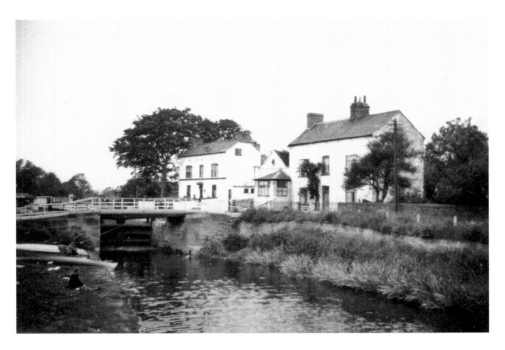

Erewash Canal, Trent Lock, 1955, and Sandiacre Lock
Above: The entrance channel from the River Trent led up to the lock. There was a small canalside community here that included a toll-house and a gauging dock. *Below*: The Erewash passed through an extensive coal and ironstone mining area, which provided important traffic for this waterway. Some canalside lock houses have survived, and among those that have is the group of buildings placed beside Sandiacre Lock. *RCHS Hugh Compton Collection 64566; Ray Shill.*

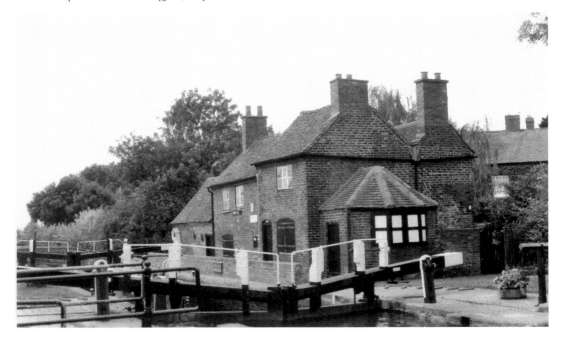

Fossdyke, Torksey Lock and Drinsey Nook

The lock at Torksey (*above*) is the only lock on the Fossdyke and is located near the junction with the River Trent. In this view the navigation continues on towards Lincoln. The Fossdyke (*below*) links the Trent with the Witham and by this link provides the navigation through the Wash and the waterways and drains of East Anglia. *RCHS Transparency Collection 56242; RCHS Hugh Compton Collection, Ian Pope 64580.*

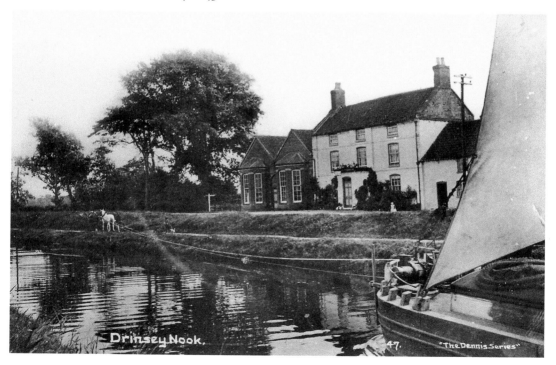

Chesterfield Canal, Norwood Bottom Locks
West of Norwood Tunnel to Staveley and Chesterfield, the Chesterfield Canal has long been disused, although the lock chambers for the former staircase locks remain intact. The old lock cottage has been enlarged and now is an extensive home and garden complete with a tall, neatly cropped hedge. In this image the bottom set of staircase locks is seen. There are another two sets of three-lock staircases and then a four-lock staircase that brought the canal up to the summit level at the West Portal of Norwood Tunnel. *Ray Shill.*

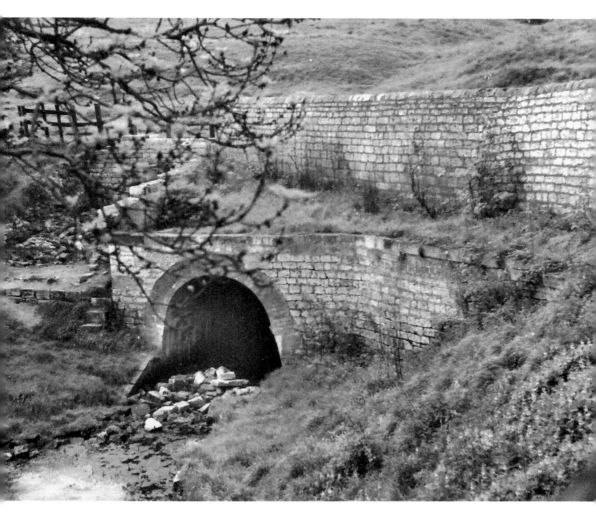

Chesterfield Canal, Norwood Tunnel East Portal
Norwood Tunnel is placed at the summit level of the Chesterfield Canal. The canal climbed through a series of locks to this point, some of which were arranged as staircases. This tunnel was lengthened, but was later closed as the result of subsidence. With this closure, which happened in the time the Great Central Railway was responsible for the tunnel, the western section to Chesterfield became isolated from the rest of the network. *RCHS Kenneth Gardiner Collection 66530.*

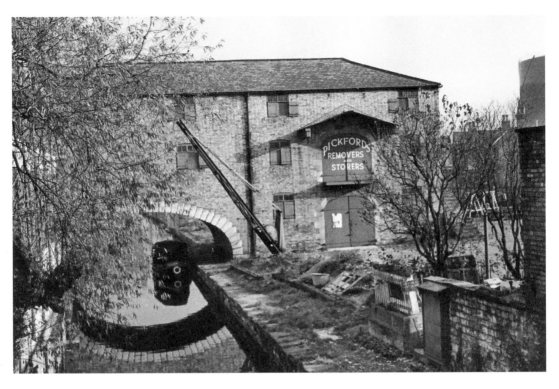

Chesterfield Canal, Worksop Warehouse

The Chesterfield Canal in Worksop was lined by various properties including a group of malthouses. Central to the town, the company wharf included a warehouse that spanned the canal. *RCHS Kenneth Gardiner Collection 66433, 66434.*

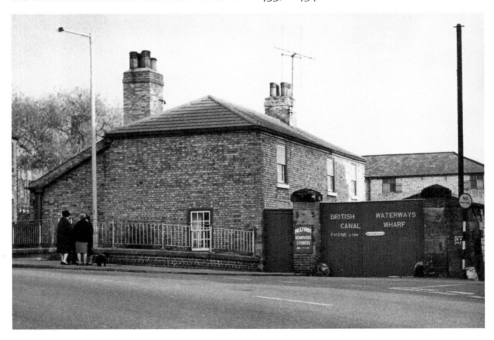

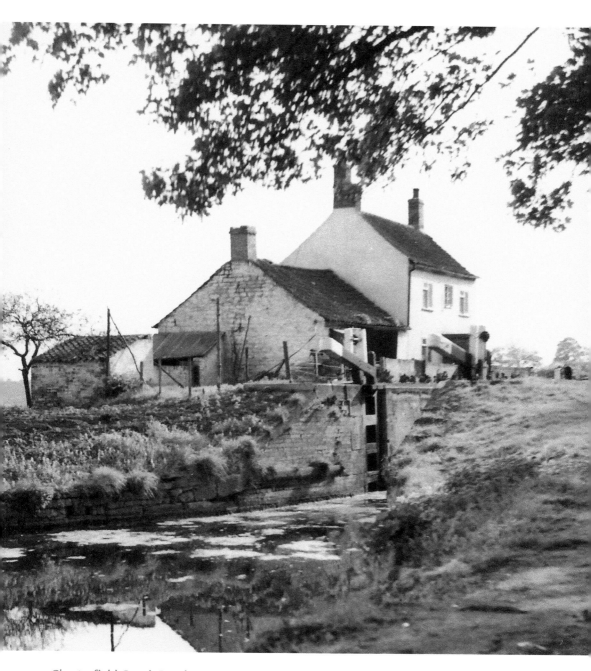

Chesterfield Canal, Barnby Foss Covert Lock, 1960
After the steep descent from Norwood Tunnel to Worksop, the distance between locks began to increase. All locks along this section passed only narrowboats. *RCHS Kenneth Gardiner Collection 66367.*

Chesterfield Canal, Flour Mill at Retford, 1978
The Chesterfield canal was drained in 1978. *RCHS Kenneth Gardiner Collection 66340.*

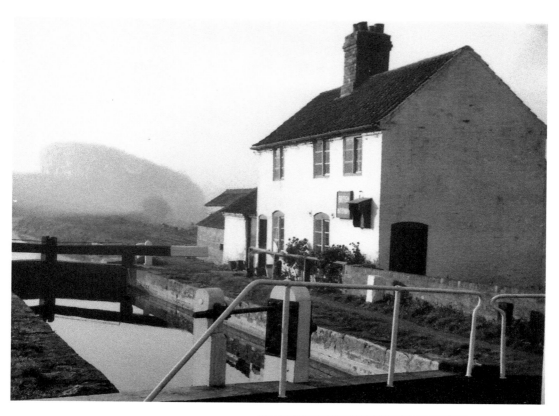

Chesterfield Canal, Gringley Top
Lock and Drakeholes Tunnel, 1960
The locks from Stockwith to Retford
were made wide enough for barge
traffic. They could also be reached by
navigation of the River Idle. With the
completion of the Chesterfield Canal,
trade on the Idle declined. *RCHS
Kenneth Gardiner Collection 66266,
66292.*

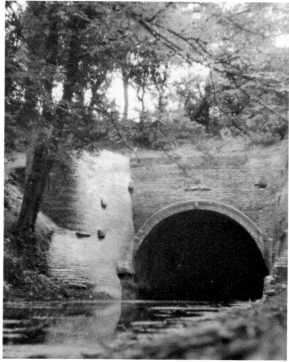

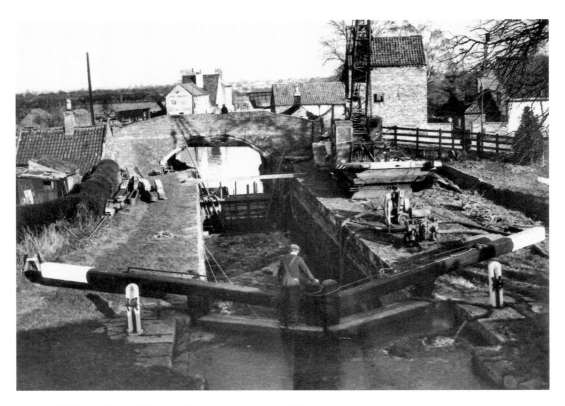

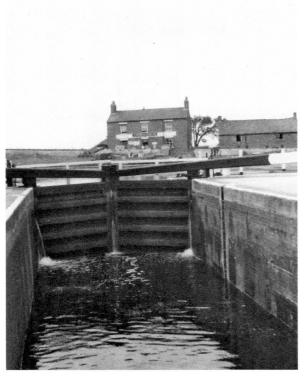

Chesterfield Canal, Misterton Top
Lock, 1967, and West Stockwith,
1960

A year before this part of the
canal was designated a cruiseway,
Misterton Top Lock is repaired
for British Waterways (*above*).
Beyond the bridge the Packet Inn
can be seen beside the towing
path. Communication between the
Trent and the Chesterfield Canal
was made at West Stockwith (*left*),
where a barge lock was provided.
*RCHS Kenneth Gardiner Collection
66227, 66207.*

Oxford Canal, Braunston

Braunston was first served by the Oxford Canal. This section was constructed to the instructions of engineer Samuel Simcox, who took over in this role following James Brindley's death in 1772. The Oxford Canal constructed a wharf beside the turnpike bridge and Pickford's later had a warehouse there. The Oxford Canal improvements (1829–34) diverted the canal along a new course to the west of the existing line. A short length of the old line remained a useful link with the Grand Junction Canal, but much of the remainder became disused. Only the section to the Oxford Canal Wharf remained in water, where the wharves were converted for use as boatbuilding yards. *RCHS Collection 40928.*

chapter three

Canal Heyday

Ashby, Cromford, Derby, Grantham, Grand Junction, Leicester, Leicestershire & Northamptonshire Union, Nottingham, Nutbrook and Oakham

During the last decade of the eighteenth century, many more canal schemes were promoted. Parliament was kept busy in the years 1792–94 when most went before the committees. This was a period that historians have called the 'Canal Mania'. Although not all schemes were successful in getting the Act through to the Royal Assent stage, the process of getting the navigation also had several hurdles to get over. Finance was all important and not always sufficient at a time when Britain was geared up for war with the French.

East Midland Navigations that were approved were a mixture of river navigations and canals. The canals were all intended to be built to barge dimensions, and four, the Cromford, Derby, Grantham and Nottingham, were completed more or less within their target dates and without major issues.

Other schemes had sections that were unfinished or little used. The Ashby Canal was started and built as a barge canal, but never reached its destination at Ashby de la Zouch. It joined the Coventry Canal at Marton Junction as the only outlet to the network, meaning that traffic was generally confined to narrowboats, and barges were restricted to internal traffic along the Ashby.

The Leicester Navigation comprised both canal and river elements: The Forest Line from Loughborough to the limestone quarries and mines to the east, and the River Line from Loughborough to West Bridge Leicester. The River Line was essentially a navigation of the Soar, with locks and lock cuts to bypass the weirs. The Forest Line had a central canal section, which saw little use. The Leicestershire & Northamptonshire Union was built with the hope of uniting the Soar with the Nene, but failed to reach the intended objective. It was built as a river navigation to Aylestone and then as a canal, finally reaching Market Harborough but going no further.

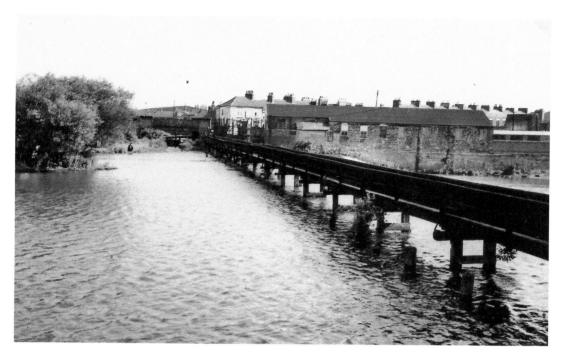

Derby Canal, Long Bridge and Sandiacre Lock, Derby, 1955

Above: At Derby the canal crossed the Derwent at right angles. A towing path bridge was provided across the river to enable boat horses to haul craft between the two halves of the canal. *Right*: The canal comprised three separate waterways that went north, east and south from the town of Derby. The eastern canal passed through Spondon to Sandiacre, where it joined the Erewash Canal. Though it was not abandoned until the 1960s, little or no traffic had passed along the canal since the 1940s. *RCHS Ray Cook Collection 60014; RCHS Hugh Compton Collection 64460.*

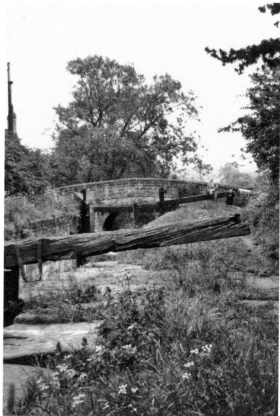

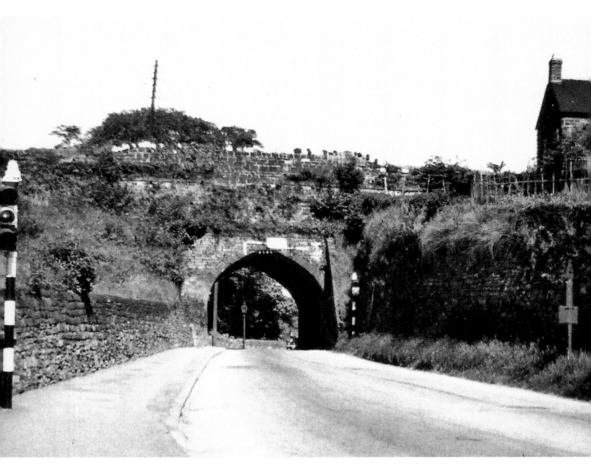

Cromford Canal, Bulls Bridge Turnpike Aqueduct, 1955

At Bulls Bridge the Cromford Canal made five crossings, over a turnpike, mill stream, railway, the River Amber and Drovers Way, in a relative short length of the waterway. While the aqueduct over the railway was made when the North Midland Railway was constructed, the stream, river and road aqueducts were contemporary with the opening of the canal in 1794. The turnpike, stream and railway aqueducts were demolished in 1968, but the other two survive. *RCHS Hugh Compton Collection 65302.*

Cromford Canal, Butterley Tunnel, West End, 1975

The Butterley Tunnel was opened with the canal in 1794, but was only 9 feet wide with 8 feet of headroom above the waterline. While the canal from Langley Mill to the top of the locks was built to barge width, that up to the tunnel and through to the terminus at Cromford was made only wide enough for narrowboat traffic. Mining in this area damaged the tunnel through subsidence and there were roof collapses. The Midland Railway Company, which came to own the canal, made repairs. However, following an inspection of the tunnel in 1909 the Midland applied for abandonment, although maintenance continued until the 1920s. The West End of Butterley Tunnel is perhaps the most altered entrance, as a result of extensions to the tunnel at various times. Initially 2,966 yards long, the length by the mid-1840s was said to be about 3,000 yards. This was extended again with the making of a branch railway across the portal during 1897, adding another 26 yards. The portal is seen in this form in the image above. Since then the A38 has been built over the canal and a new tunnel entrance created for the water that still flows through the tunnel. *RCHS Hugh Compton Collection 64427.*

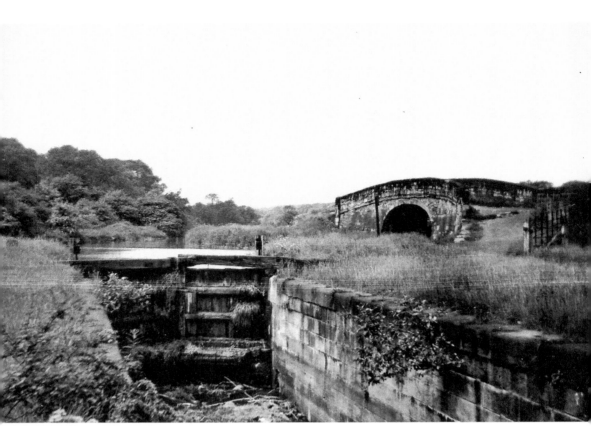

Cromford Canal, Top Lock, 1955

The Cromford Canal climbed up to the summit level near Codnor. Here the canal divided: the main line turned left, while right through the bridge was the Pinxton Arm, which terminated at Pinxton Wharf. *RCHS Photograph Collection 64429.*

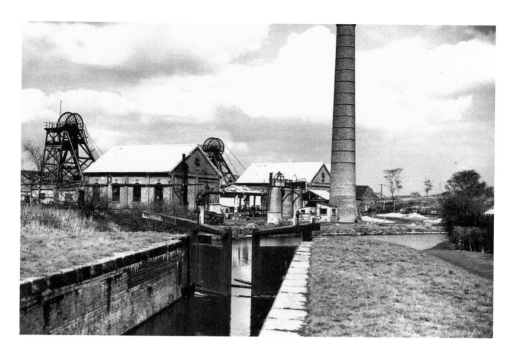

Nottingham Canal, Lock 19 at Wollaton Colliery and Bramcote Moor Bridge, 1960
Most of the Nottingham Canal was disused by 1960 when these pictures were taken. Yet, very much active at this time was Wollaton Colliery, which sent coal out by rail. The canal climbed to the summit level at the top of this lock and then followed the contours of the Erewash Valley towards Langley Mill. Even though the Nottingham Canal had been abandoned for over twenty years, a pair of sunken barges remained at Bramcote Moor Bridge, as seen in the image below. *RCHS Hugh Compton Collection, photographer C. W. Hage 65286, 65294.*

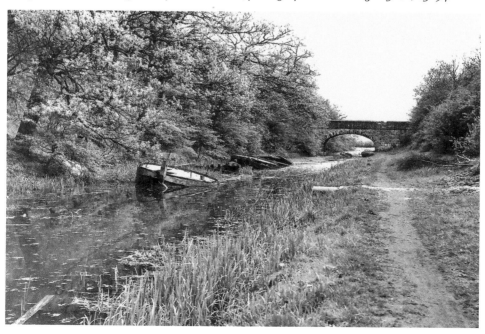

Nottingham Canal, Langley Mill, 1960

When the Nottingham and Cromford Canals were constructed, a through-route was opened between Nottingham and many principal ironworks, coal mines and limestone quarries in the East Midlands. Langley Mill was the junction point between the Nottingham and the Cromford. *RCHS Hugh Compton Collection, photographer C. W. Hage 65305.*

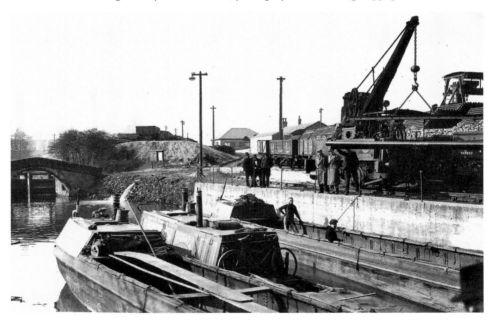

Nutbrook Canal, Stanton Ironworks Wharf, c. 1937

The Nutbrook Canal was built as an independent waterway to serve mines and ironworks. Although the bulk of the canal fell into disuse, a section was retained to serve the Stanton Ironworks, which regularly sent out pipes by boat. *RCHS Hugh Compton Collection 65316.*

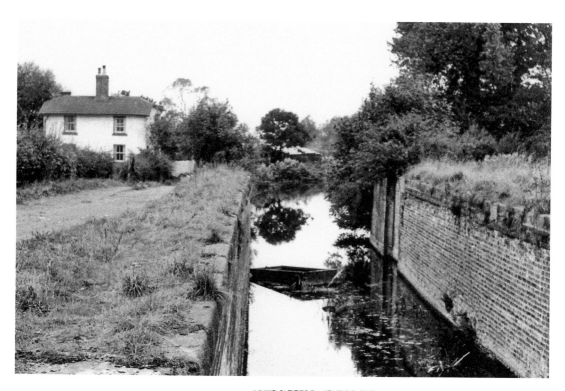

Grantham Canal, Lock 4, 1967, and Fosse Upper Lock and Wharf Buildings, 1967

In the above view of the Grantham, the lock chamber shows evidence of maintenance and there is also an occupied lock cottage. In the image to the right, the dry bed of the Grantham Canal is seen from the A46 roadbridge looking towards the top lock (No. 11) and the derelict wharf buildings near the lock-side. *RCHS Kenneth Gardiner Collection 67017, 67033.*

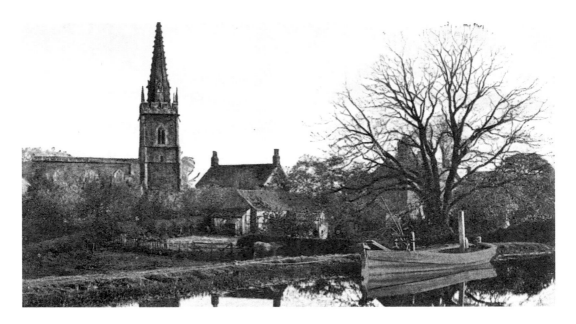

Grantham Canal, Redmile
Trade on the Grantham included the carriage of coal from the Nottingham pits, yet essentially it served farming and agriculture. Rural settings such as Redmile were a common feature of this waterway. *RCHS Postcard Collection 96261.*

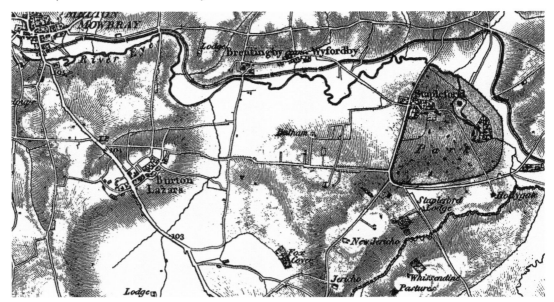

Oakham Canal, Melton to Saxby
The Oakham Canal climbed up the side of the Eye valley, rising by 126 feet and nineteen locks to Edmonthorpe. The route was 15¼ miles long and was finally completed during 1802, although an opening to Oakham Wharf and Basin was made in 1803. This section of the route is reproduced from the early Ordnance Survey of the 1830s and shows the canal route before the Syston & Peterborough Railway was constructed.

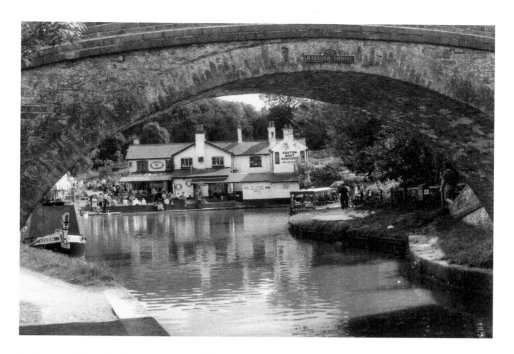

Leicestershire & Northamptonshire Union Canal, Rainbow Bridge, Foxton, and Saddington Tunnel, South-East Portal, 1955

The junction between the Leicestershire & Northamptonshire Union Canal and the original Grand Union Canal was made at Foxton. In the above view, the L&NU 'barge' route to Market Harborough is to the left, while the bottom lock of the lower Foxton staircase set for narrowboats is on the right. The canal climbed up to a summit level near Saddington where there was a tunnel under the hillside (*below*). *Ray Shill; RCHS Hugh Compton Collection, photographer Charles Hadfield 65026.*

Grand Junction Canal, Saddington Tunnel, North-West Portal, and Braunston Engine House, 1996 and 2008

Water supply was an important factor for any navigation; for the Grand Junction Canal that supply had to cope with the needs of two summits, at Braunston and at Tring. Reservoirs and streams were supplemented by engines pumping water back to the summit. *RCHS Transparency Collection 42068; Ray Shill (below and opposite).*

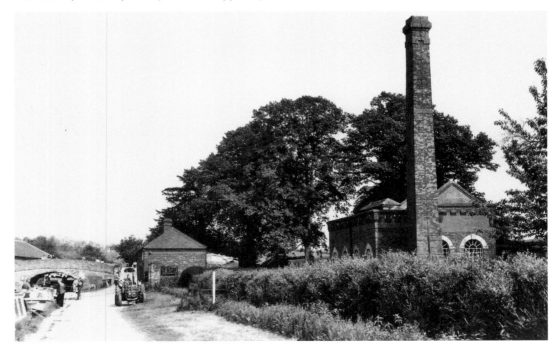

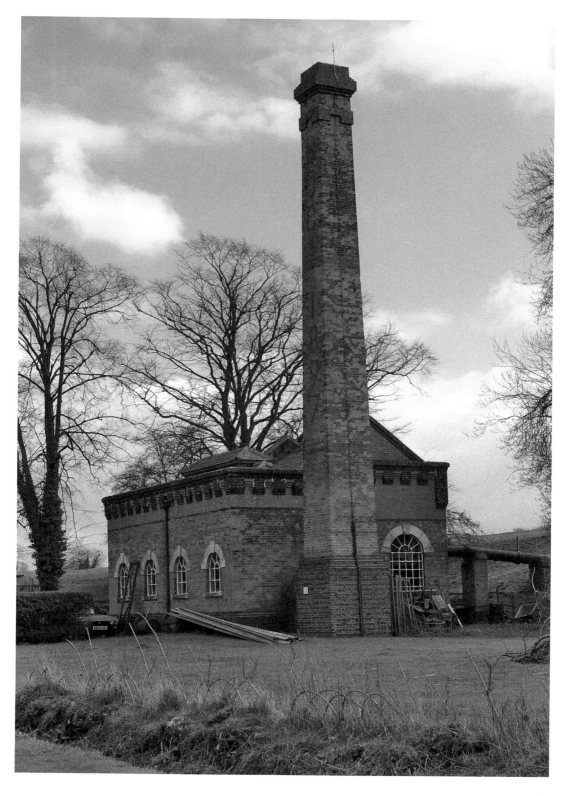

41

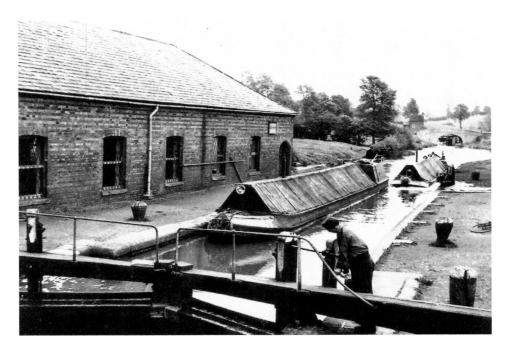

Grand Junction Canal, Braunston Bottom Lock, 1954, and Former Gauging Station, 2008
The Grand Junction Canal was the second canal project to be started in Braunston, and construction of the canal here was carried out during the last few years of the eighteenth century. The canal at Braunston climbed six locks to a summit level before descending again at Buckby Locks. Beside the bottom lock the canal company built a gauging station for boats using the waterway. The Grand Junction chose to use dry inch gauging. A series of weights placed in the hold of a boat enabled the company to produce a gauging table for each boat, which was used to verify the weight of cargo when checked by a toll collector.
RCHS Hugh Compton Collection, photographer F. Watson 64682; Ray Shill.

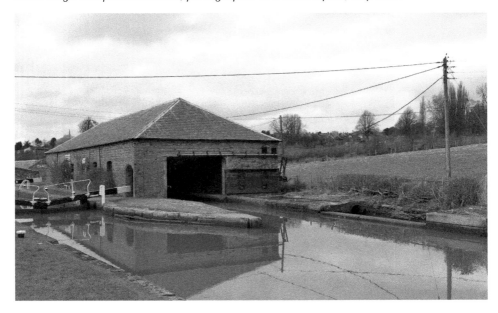

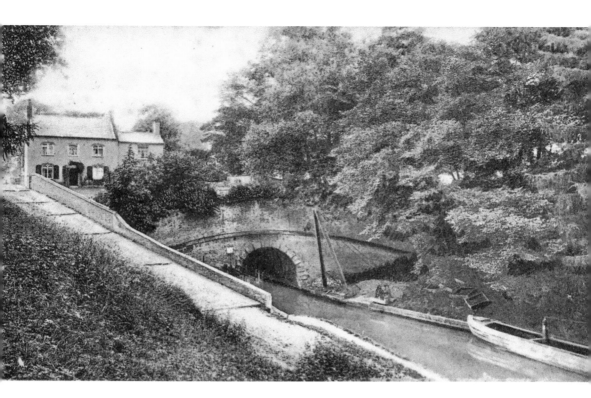

Grand Junction Canal, Braunston Tunnel

Braunston Tunnel was on a summit level of the canal. It was made wide enough for barges, but like all tunnels on this navigation it lacked a towing path. All horse-drawn craft had to be 'legged' through and the horses were taken over the top and regained the towpath by the long slope down from the top. *RCHS Postcard Collection 96091.*

GRAND JUNCTION CANAL – The Public are herby informed. That the whole Line of this Canal, from the Oxford Canal at Braunston, to the River Thames at Braunston, together with the Branches to Buckingham, Wendover, and Paddington (except the intended Tunnel at Blisworth, where an iron railway has been executed for facilitating the conveyance of all articles during the execution of the said tunnel), are now navigable; but as the Towing-Paths of the New Parts of the Works, and the erection of proper Warehouses, Shed, Cranes, and other conveniences, at Paddington, will not be in a state sufficiently accommodating to receive the General Merchandise before the 10th July next, the opening of these New Parts of the undertaking, for the General Trade, will be postponed till the said 10th day of July; when the whole Line is intended to be opened, and a Passage-Boat will be immediately after be established to and from Uxbridge.
By Order of the Committee,
Fludyer-street GRAY and CHAPLIN
June 8, 1801 Clerks to the Company

Notice published in the Morning Post, *18 June 1801*

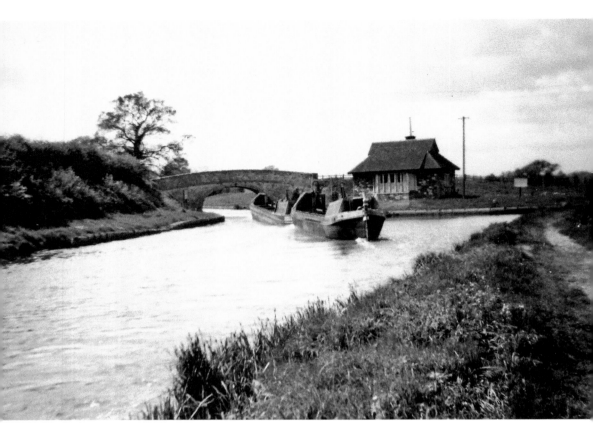

Grand Junction Canal, Norton Junction, 1955

The 'old' Grand Union Canal, which linked the Grand Junction Canal with the Leicestershire & Northamptonshire Canal, joined the Grand Junction at Norton on the Braunston summit level. Boats travelling onto Foxton and Leicester turned right here, while the route to Braunston and the Oxford Canal lay to the left. *RCHS Hugh Compton Collection 64753.*

Grand Junction Canal, Daventry & Weedon Beck

Carey produced a volume of maps that showed the canal and turnpike network during the period many canals were being built. His maps bear the date 1796 and are based on what was built and to be built according to parliamentary plans. Daventry, which lay on the main road between the West Midlands and London, was to have a branch from the Grand Junction Canal but this was never made, although a feeder from Daventry Reservoir did have a parallel course. The Grand Junction had two aqueducts at Weedon Beck – one was north of the village and the other south. That to the north crossed the turnpike to Daventry. This was once a busy route for wagons and stagecoaches travelling between Birmingham, Coventry and London. In the distance, the road joined Watling Street (A5). *Ray Shill.*

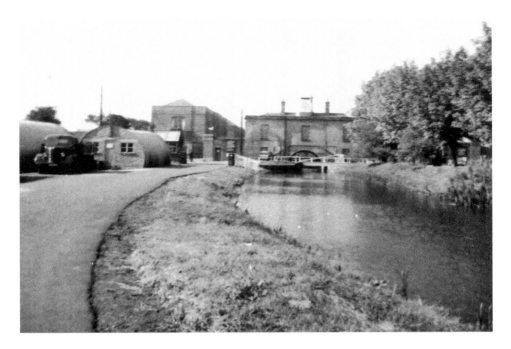

Grand Junction Canal, Weedon Beck, Weedon Ordnance Depot Canal and Stores Section, 1961

The Weedon Ordnance Depot was linked by a private canal (1804) that joined the Grand Junction Canal at Weedon Beck. The canal comprised four main sections: the first was the link canal from the Grand Junction Canal to the depot (*above*), the second was the stores section (*below*), the third a basin that enabled craft to turn and the fourth a waterway that served the magazine depot. *RCHS Photograph Collection, photographer A. H. Faulkener 64786, 64778.*

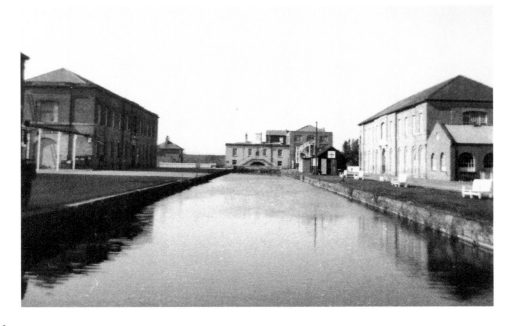

Grand Junction Canal, Weedon Beck, East Gatehouse, Weedon Ordnance Canal, 2008
There are three gatehouses on this private canal. The most accessible is the east gatehouse, where the ordnance canal entered the stores area. *Ray Shill.*

Grand Junction Canal, The Magazine, Weedon Ordnance Depot, 1961 and 2008
The Weedon Ordnance Canal was a long, straight waterway that cut through the extensive site. These powder stores were placed at the far end of the waterway. In the upper image the view is towards the stores depot gatehouse. The lower, more modern view is towards the West End Gatehouse, where the canal extended a few yards beyond. Reeds now fill the clear channel seen in the image above. *RCHS Photograph Collection, photographer A. H. Faulkener 64775; Ray Shill.*

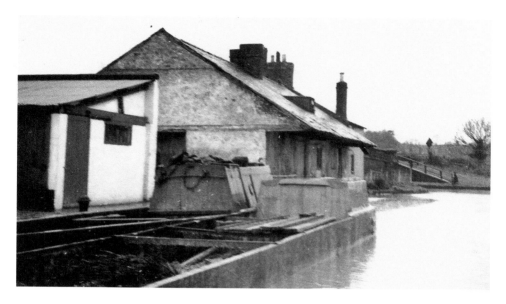

Grand Junction Canal, Gayton Workshops, 1955, and Lock 17, Northampton Branch, 2011
Above: Northampton was served by the Nene Navigation, and with the promotion of the Grand Junction Canal plans were conceived for a barge canal to the Nene. This link was not made. Instead a tramway was constructed to link Gayton on the Grand Junction Canal with the Nene at Northampton. This arrangement proved to be temporary and in 1815 the tramway was replaced by a canal suited only for the narrowboats. Craft descended from Gayton Junction through seventeen locks and the junction with the Nene. *Below*: The Grand Junction branch to Northampton was built first as a tramway and then converted into a canal that joined the Grand Junction with the River Nene. In this view, beyond the lock gate is the canal channel that joined up the Nene and the Nene, or Nine, Navigation that extended through Peterborough and the Wash. This area was also the intended destination of the Leicester & Northamptonshire Union Canal, which in fact only reached Market Harborough. *RCHS Hugh Compton Collection 64771; Ray Shill.*

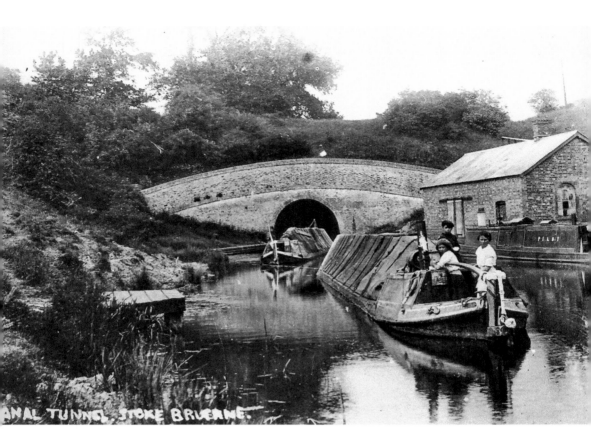

ANAL TUNNEL STOKE BRUERNE.

Grand Junction Canal, Blisworth Tunnel, South Portal, Stroke Bruerne

Making Blisworth Tunnel proved to be the longest construction project along the line of the Grand Junction Canal, with the task of excavation and lining being finished in February 1805, nearly four years after the rest of the canal was opened for traffic. All traffic passing between Blisworth and Stoke Bruerne was taken over the top of the tunnel along a tramway that carried goods and minerals between the two navigation termini. With the opening of the tunnel, boats were able to pass through the tunnel by 'legging'. Later, mechanical propulsion was introduced, with tunnel tugs hauling craft through. In this view the steam tug *Pilot* can be seen moored on the right. *RCHS Hugh Compton Collection, Neil Parkhouse/Ian Pope 64740.*

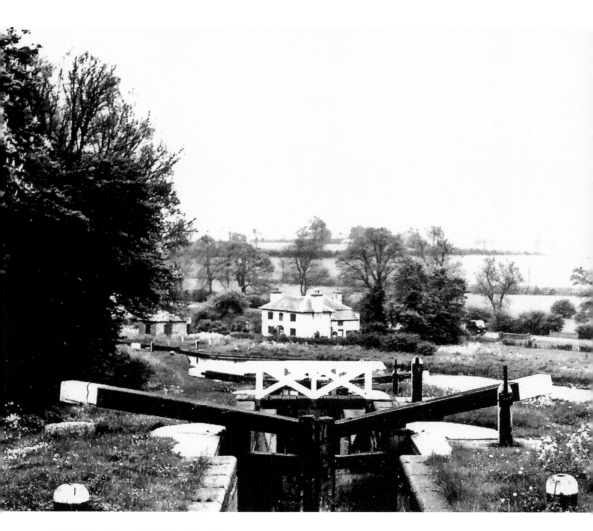

Old Union Canal, Watford Locks, 1953

While the Grand Junction Canal made no link with the Leicestershire waterways at Northampton, the Old Union Canal did finally make that link. This was done through tunnelling and the making of two flights of locks. The canal at Watford was carried up to the summit level, which consisted of conventional locks and a staircase triple. Despite the improvements made at the other end of the summit at Foxton no incline plane was installed at Watford and so the potential to move coal from the East Midlands in barges never materialised. *RCHS Hugh Compton Collection, photographer F. Watson 64797.*

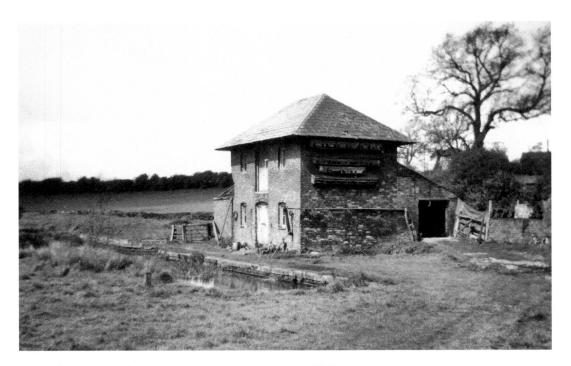

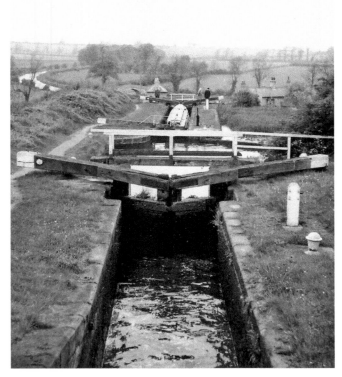

Old Union Canal, Welford Basin, 1955, and Foxton Locks, 1953

The original Grand Union Canal had a single navigable branch to Welford, where a feeder from the reservoirs joined the navigation. The Welford Arm was a short branch whose terminus wharf was placed near the turnpike. It also provided the means of linking the Grand Junction Canal with the Leicestershire & Northamptonshire Canal at Foxton. This waterway had a long summit level from the top of Watford Locks to Foxton. Here the nature of the terrain led to a sharp descent to the Leicestershire barge waterway. Two sets of staircases, each with five locks in the set, were provided, together with side pounds to conserve water for the passing craft. *RCHS Hugh Compton Collection 64815, photographer F. Watson 64801.*

Old Union Canal, Towpath Bridge, Husbands Bosworth, 1955, and Husbands Bosworth Tunnel Portal, 2002

Though the canal tunnel was completed in 1813, the associated towpath route over the tunnel was diverted with the completion of the Rugby–Stamford Railway and the horse route was carried across a three-arch bridge. *RCHS Hugh Compton Collection 64810; Ray Shill.*

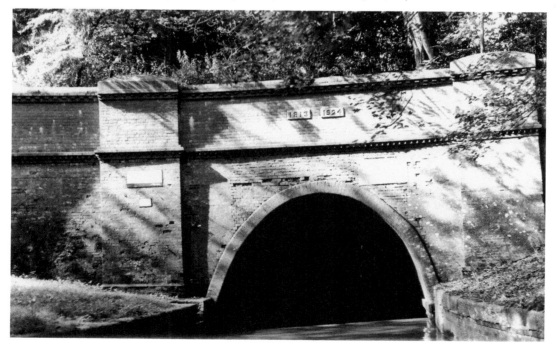

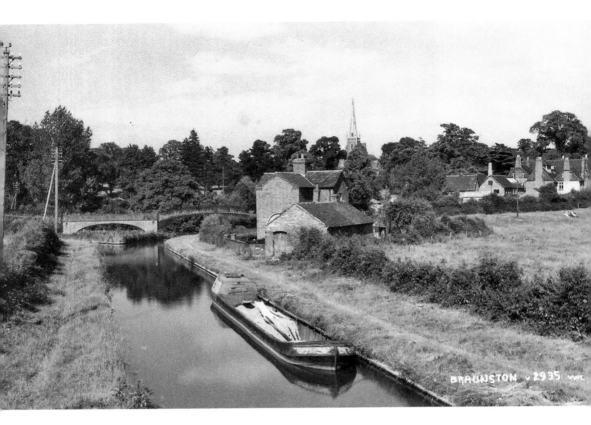

Oxford Canal, Braunston

The contractors came back to Braunston for a third time for the reconstruction and diversion of parts of the Oxford Canal (1829–34). The work at Braunston included a diversion of the canal to Napton along a straighter course with an embankment and aqueduct over the River Leam. Part of the work involved the construction of a 'Y' shaped junction. On the approach from Napton craft turned right for the Grand Junction Canal or left to travel on to Hillmorton. Both arms of the junction were crossed by the Horseley Iron Company Bridge, which carried the towing path over the canal. *RCHS Postcard Collection 97080.*

chapter four

Inland Ports

Gainsborough, Shardlow

There are certain places on the British navigation network where merchandise and minerals were trans-shipped between craft. In the West Midlands both Stourport and Diglis (Worcester) were inland ports on the Severn at which narrowboats exchanged cargoes with river craft, trows and barges, for the southward journey to Gloucester or Bristol, or upstream for Bridgnorth, Ironbridge or Shrewsbury.

In the East Midlands, Shardlow became an interchange point for narrowboat traffic from Birmingham, South Staffordshire and the Potteries, and Trent Boats travelling to the Fossdyke, Gainsborough, Nottingham or Stocksbridge.

Gainsborough was equally an important inland port, as the limit of Trent Boat traffic. Here goods and minerals were exchanged again, with larger craft carrying them onto Hull, the Yorkshire Ouse or along the coast to destinations including London.

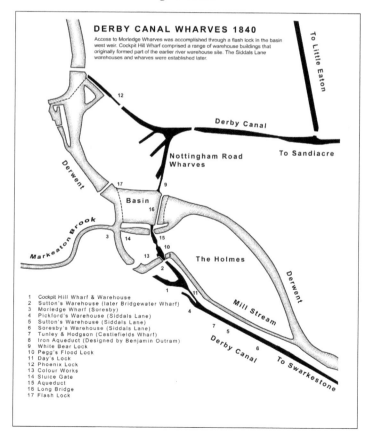

DERBY CANAL WHARVES 1840

Access to Morledge Wharves was accomplished through a flash lock in the basin west weir. Cockpit Hill Wharf comprised a range of warehouse buildings that originally formed part of the earlier river warehouse site. The Siddals Lane warehouses and wharves were established later.

1 Cockpit Hill Wharf & Warehouse
2 Sutton's Warehouse (later Bridgewater Wharf)
3 Morledge Wharf (Soresby)
4 Pickford's Warehouse (Siddals Lane)
5 Sutton's Warehouse (Siddals Lane)
6 Soresby's Warehouse (Siddals Lane)
7 Tunley & Hodgson (Castlefields Wharf)
8 Iron Aqueduct (Designed by Benjamin Outram)
9 White Bear Lock
10 Pegg's Flood Lock
11 Day's Lock
12 Phoenix Lock
13 Colour Works
14 Sluice Gate
15 Aqueduct
16 Long Bridge
17 Flash Lock

City Canal Wharves

In addition to Shardlow and Gainsborough both Derby and Nottingham had wharves where narrow boats could exchange their cargo with Trent Boats or road wagons that conveyed merchandise along turnpikes through the Peak District to Manchester, Sheffield, Leeds or York.

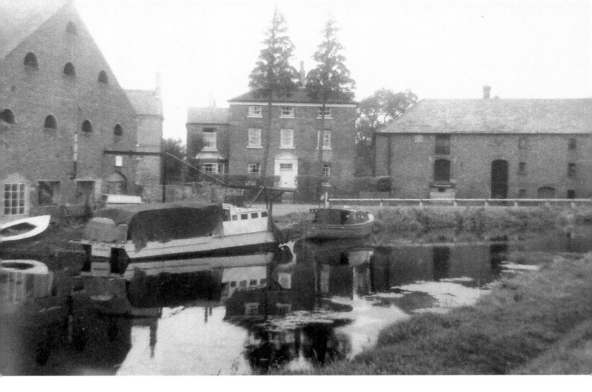

Trent & Mersey Canal, Wharf and Warehouses, Shardlow
RCHS Hugh Compton Collection 65815; Ray Shill.

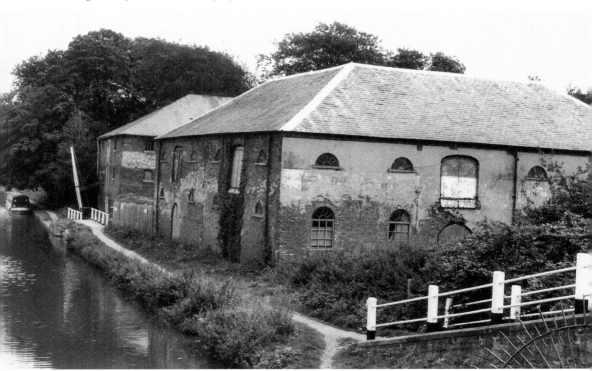

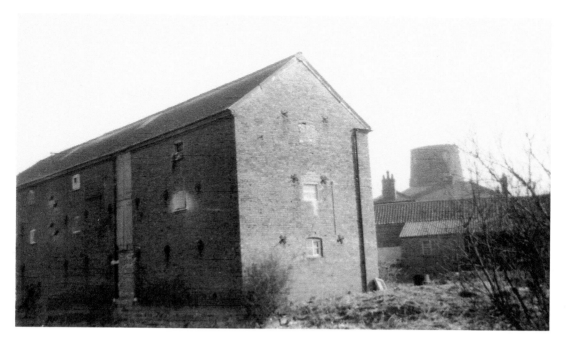

Trent & Mersey Canal, Great Wharf, Past and Present

There was a group of warehouses close to the London Road that formed part of the original wharf there, known as the Great Wharf. The warehouse (*above*) is shown in its 1950s state of repair. A more recent view of the same warehouse (*below*), shows a modern use for the structure, which developers have sympathetically restored for use as apartments. *RCHS Hugh Compton Collection 65811, Ray Shill.*

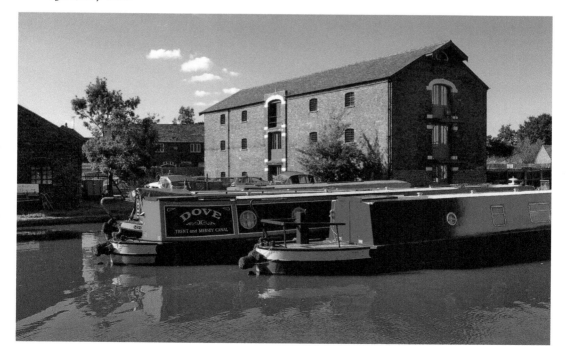

Trent & Mersey Canal, London Road Wharf, 2006
One of the oldest surviving warehouses at Shardlow is placed beside the London Road. *Ray Shill.*

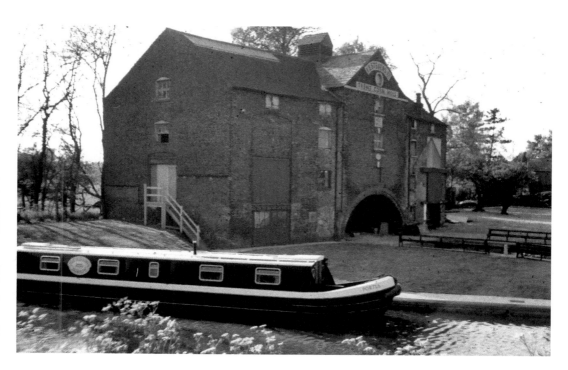

Trent & Mersey Canal, Clock Warehouse, London Road Wharf, Shardlow, 1977
The distinctive Clock Warehouse was placed on the west side of the group of Shardlow wharves and bears a date-stone that reads 1780. Complete with an inside loading basin, this building was for a long time in the ownership of the Trent & Mersey Canal, although it appears it was one of a group of properties initially owned by the Cavendish Boat Company. In this view the building had been converted for use as the Trent Corn Mill. The Clock Warehouse, after a period of use as a flour mill, was converted to a public house. *RCHS Transparency Collection 76421; Ray Shill.*

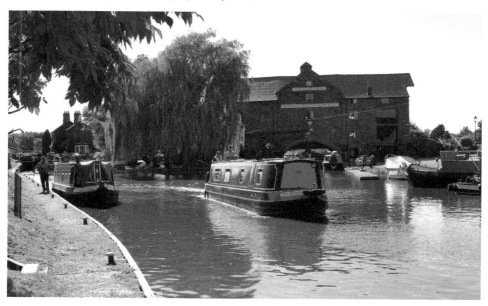

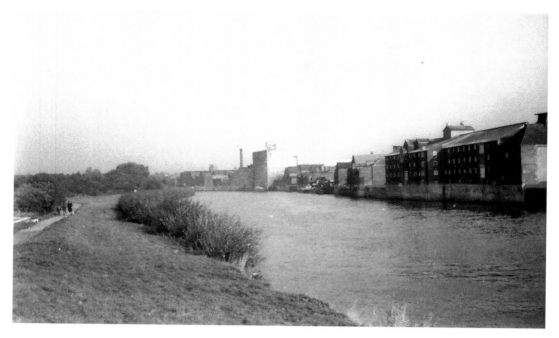

This page and opposite: River Trent, Gainsborough

Seen on this page and the next, the Trent at Gainsborough was a physical barrier that separated Nottinghamshire (left-hand shore) from Lincolnshire (right-hand shore). It afforded, at this spot, a draught of up to 12 feet for vessels. Coastal sailing craft started their journey from a group of wharves placed along the Lincolnshire bank. During the eighteenth century, contract vessels were trading between these wharves and Irongate Wharf on the Thames in London, exchanging goods between coastal trading vessels and Trent Boats. *RCHS Hugh Compton Collection, photographer A. P. Voce 65760; RCHS 40772; Ray Shill; RCHS 40765.*

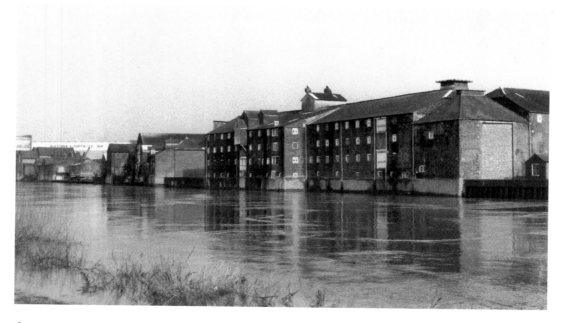

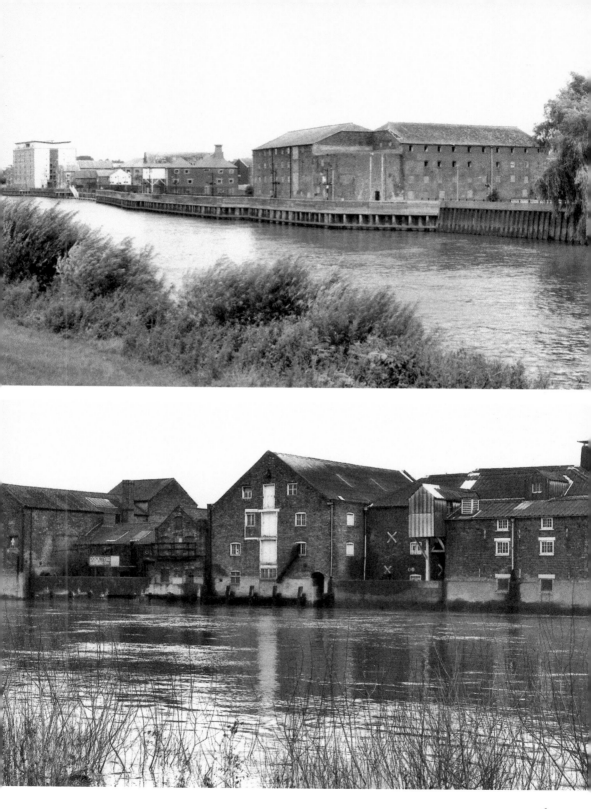

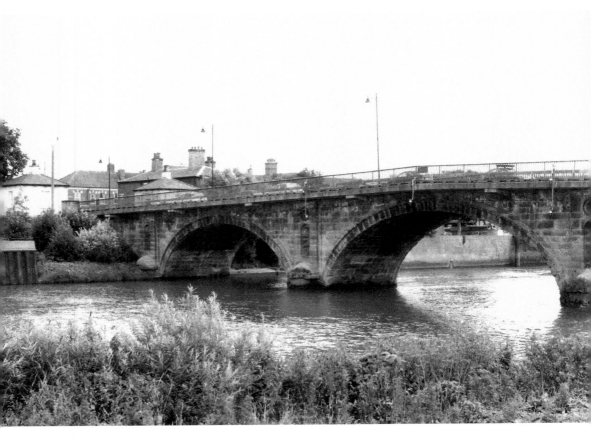

Gainsborough Bridge, 2005

The toll-bridge over the Trent at Gainsborough was sanctioned by Act of Parliament in 1787 and opened to traffic during 1791. The foundation stone was laid on 19 October 1787, and when complete this three-arch stone bridge had a total length of 328 feet. Two of the arches had a span of 62 feet each, while the central arch was 70 feet. The bridge replaced a ferry, which on occasions had been lost in high tides or stormy weather. *Ray Shill.*

chapter five

The Railway Age

Ashby & Ticknall Plateway, Coleorton Railway, Cromford & High Peak Railway, Leicester & Swannington Railway, Little Eaton Gangroad and Mansfield & Pinxton Railway

Changing ground levels did not always suit canal construction. There were parts of the East Midlands where the companies chose not to build waterways, instead opting for a connecting form of 'railway' to reach the higher ground as an extension to their canal network.

This was a time when the railway was finding increasing use in moving goods and merchandise. Contemporary technological innovation drew on the improved methods of iron manufacture and the increased availability of cast iron. While there were a number of variations, essentially there were two main types of railway then in use. These were the edge rail and the plate rail. Edge rails were cast iron and the wheels of the wagon ran along the top of the rail, while in the plate rail system the wagon wheels rested on the bottom of the plate.

Local engineer Benjamin Outram pioneered plate railways in the East Midlands including those serving canals. The Ashby and Derby Canal Companies elected to build 'plateways' to serve mines and quarries. The Leicester Canal Navigation Forest Line had two separate plateway sections that served as part of the route. Private businessmen also made tramways or plateways from mines, works and quarries to the nearest waterway. Some of these incorporated rope-worked inclines.

There were also two 'public railway companies' that served the Cromford Canal. One was the Mansfield & Pinxton Railway, a private railway company set up to build and operate a railway from the terminus of the Pinxton Branch of the Cromford Canal to Mansfield. The second was the long Cromford & High Peak Railway that connected the Cromford Canal at Cromford Wharf with a terminus of the Peak Forest Canal at Whalley Bridge.

Canal-owned Railways

Ashby Canal: to Ticknall
Charnwood Forest Canal: Loughborough Wharf to Nantpantan; Thringstone to Coleorton; Osgathorpe to Barrow Hill
Derby Canal: Little Eaton to Denby
Grand Junction Canal: Gayton to Northampton; Blisworth to Stoke Bruerne

Public Railways

Coleorton Railway
Cromford & High Peak
Leicester & Swannington
Mansfield & Pinxton

There were a number of privately owned 'industrial' tramways that served mines and quarries and brought minerals down to wharves alongside the East Midland Waterways. Included in this group is the Belvoir Castle Railway, laid with edge rails, that connected Belvoir Castle (Earl of Rutland) with the Grantham Canal.

The creation of the passenger railway network was an important development. Some of the many railway companies that emerged in this period purchased or took over canals to assist the development of their undertakings.

The Oakham Canal was an early battleground for the competition between railways and canals. Attempts to link Oakham with Stamford by canal or railway had been unsuccessful until the Syston to Peterborough Railway scheme of 1844. The route passed beside and across the line of the Oakham Canal. When surveyors acting for the Midland Railway Company made their way along the towpath of the canal alongside the estate of Lord Harborough, estate workers set upon the surveyor's party, confiscating equipment. The next day the railway men returned and, at times, battled with Lord Harborough's men, and again were repelled. The Midland Railway Company remained undaunted, however, and in 1845 purchased the canal to incorporate the route into their new 48-mile-long railway. Between 1846 and 1848 contractors constructed the railway, cutting off sections of the canal line and rendering most parts dry.

The railway was a very different type of conveyance to the canal, with a different agenda and different policy for carriage. It was one that catered chiefly for passengers and had, initially, a restricted view of freight conveyance. For example, local movement of coal from the Wreak Navigation was not considered part of the Syston to Peterborough Railway scheme. The Oakham Canal proprietors had been in a habit of carrying coal from Melton to Oakham, but when the canal was closed and the bed became dry, one Oakham businessman, J. Johnson, tried to sue the Midland Railway Company after it refused to carry his coal from Melton. The Midland believed that wagons should be provided for the trade by carriers, which was very different to the previous arrangement, where the canal company did. Johnson's case was successful in the local court, but the decision was reversed on appeal.

The Midland also acquired the Ashby Canal, but kept this waterway open. However, the company took some of the connected plateways for rebuilding as standard gauge mineral railways.

Railway construction also created new canalside infrastructure, with bridge and viaducts spanning the waterways and new aqueducts to carry them over railway tracks. There is a whole spectrum of railway design in this sector, from masonry through to iron and steel. The later railway incursions into Derbyshire, Nottinghamshire and Leicestershire often included substantial infrastructure, such as long brick viaducts like the Great Central Railway at Leicester or the Great Northern Railway at Awsworth, iron-bridge spans, or viaducts like the Great Northern Viaduct at Bennerley.

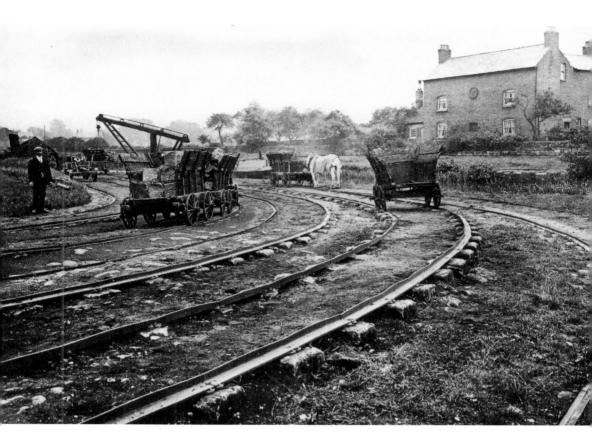

Derby Canal, Little Eaton Wharf and Plateway

The Derby Canal Company was responsible for the construction and operation of the Little Eaton Gangroad, which served various coal mines and Denby Pottery. It was a type of tramway known as a plateway, which had L-shaped rails with the wagon wheels running on the flat part of the plate. *RCHS Photograph Archive, Bertram Baxter Collection 21819.*

Cromford Canal, Pinxton Wharf and Cast Iron Rail

The decaying scene at Pinxton Wharf (*above*) was once a busy railway and canal interchange. Pinxton Wharf was at the end of the Pinxton Branch, but was also the start of the Mansfield & Pinxton Railway. Carriers on the canal would interchange goods here between boat and railway wagon. While many canal railways in this region favoured the plateway, the Mansfield & Pinxton Railway had edge rails. This early type of cast-iron 'fish bellied' rail (*below*) formed the track. Such railways were the forerunner of the modern railways, but unlike our modern networks, where tracks are laid on sleepers, these iron rails were laid (like the plateway) on stone blocks. *RCHS Baxter Collection 21130, 21127.*

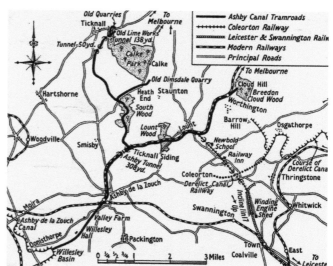

Ashby and Swadlincote
The Railways of Ashby and Swadlincote served mines and limestone quarries. The early railways began as canal feeders for the Ashby Canal or the Forest Line for the Leicester Navigation. *Baxter Collection.*

Grantham Canal, Midland Railway, Nottingham & Melton Line
Though the Grantham Canal ceased to be used in the 1920s, the waterway at Nottingham retained water for many years. In this 1967 view the Nottingham to Melton Mowbray Line can be seen crossing the canal, which was still a popular location for fishermen. *RCHS Kenneth Gardiner 67012.*

chapter six

Canal and River Improvement Schemes

River Soar, River Trent, Foxton Incline Plane

Construction technology improved during the nineteenth century as contractors honed their skills building tramroads and railways. Improving the Trent was a long-held vision of the Trent Navigation Company, but little had been done since their lock-building phase during the last decade of the eighteenth century. Like on the Severn, various new schemes came to naught, but finally, at the start of the twentieth century, a scheme was proposed for making new locks from Nottingham through to Newark and at Cromwell. Newark Town Lock was reconstructed and Cromwell Lock made, but the intermediate improvements were put on hold and it was not until the 1920s that Nottingham Corporation succeeded in making these new locks and deepening the river so that larger vessels could reach the new port at Nottingham.

The River Soar was improved for a very different reason; flooding of the river was prevalent along its banks. While farmers benefited from this irrigation of their lands, the townspeople and industrialists of Leicester endured frequent inconveniences. Leicester Council embarked on a plan to reduce the effects of flooding in their town during the 1860s, but initial schemes were never realised. More determined efforts were made from the mid-1870s when a plan was conceived to lower the riverbed in places and straighten sections of the navigations. It was a scheme that changed as the work progressed, but can be divided into two major parts. The first involved deepening the Soar near the Abbey. The council chose also to create a new park in the process, using the land gained from the straightening of the river there. Such work also affected the Leicester Navigation, as one lock had to be moved and a new lock was required near the public wharf. In order not to disrupt trade on the navigation, a temporary lock and navigation was put into use at Abbey Corner while the work was underway. The work was gradually extended through Leicester to Freeman's Meadow on the Leicestershire & Northamptonshire Union Canal. Another new lock here replaced two that were removed when the canal between Freemans Meadow and the West Bridge was straightened.

The second and perhaps more difficult part of the work was the diversion of the Leicestershire & Northamptonshire Union Canal onto a new route, the building of a new lock and weir, the replacement of West Gate Bridge and the deepening of the Soar there.

Navigation owners also looked abroad for inspiration, and for a time waterway development in Europe encouraged British canal companies to also strive for expansion and finance new infrastructure. Yet while European waterways continued to improve, few British Waterways were willing to invest in similar ventures, and those that did utilised British innovation and invention.

One example was the Foxton Incline Plane, which was intended to assist the busy Foxton Locks, then a major bottleneck to trade. The plane had the advantage that it could carry either a Trent Boat or a pair of narrowboats. Unfortunately the Old Union was only capable of passing narrowboats, so lift usage was light.

Improvements to the Trent Navigation were also contemplated with a scheme proposed to take boats as far as Birmingham. Such plans failed to materialise. Only the lock at Cranfleet was deepened during this period. Another navigation 'improvement' was made between Clifton and Nottingham (Trent Bridge) for coal traffic. The Manchester, Sheffield & Lincolnshire Railway made alterations to a section of the Chesterfield Canal between 1890 and 1892. A length near Killamarsh was straightened to make way for the construction of their new main line that would be made south to Nottingham, Leicester, Rugby and London.

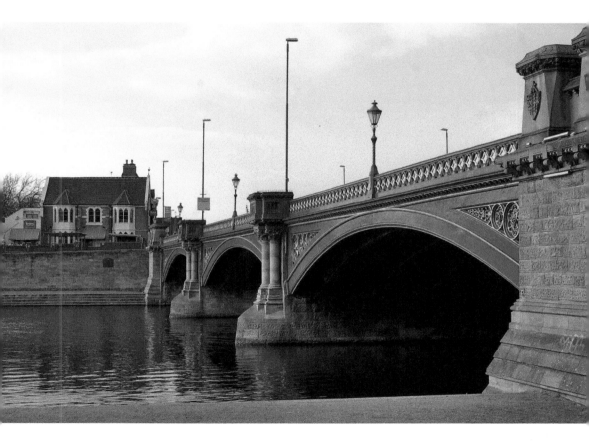

Trent Bridge, Nottingham
The crossing of the Trent at Nottingham was made by a medieval stone bridge of many arches, and only a few of the arches were wide enough to pass Trent Boats. While the navigation of Trent Boats had been reduced, the sinking of a new colliery at Clifton and reinstatement of the navigation to Clifton influenced the replacement of Trent Bridge with a new iron and stone structure. The iron parts were supplied by A. Handyside of Derby, while Benton & Woodiwiss were contracted for the stonework. Work commenced in 1868 and the bridge was open for traffic in 1871. The main channel was spanned by three cast-iron arches, each 100 feet in width. During the 1920s, Trent Bridge was widened by the Cleveland Bridge & Engineering Company. *Ray Shill.*

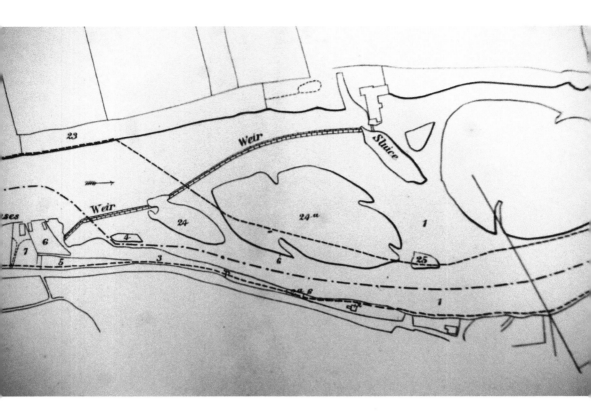

Above: Upper Trent Navigation, Kings Mills
While navigation ceased on most sections of the Trent above Shardlow, there was a plan to restore navigation in 1888 and extend it through to Birmingham using the River Tame (Birmingham & Humber scheme). This section of the deposited plan shows the intended navigation through the weir at Kings Mill. The original lock here was located on the left-hand side of the weir near the figure 6.

Opposite: Leicester Navigation, Great Central Railway Bridge and Evans Weir, Leicester
Top: When the Great Central Railway Extension to London Marylebone was completed in 1900, the route through Leicester ran close to the Soar, crossing the river and towering over the West Bridge. Wolverhampton-based Henry Lovatt was responsible for completing this part, as well as the passenger station at Leicester. The river here had been improved and deepened as part of the Leicester flood relief programme (1878–90). Some of the factories, which lined the riverbank, are to be seen in this view, as is the handrail for the West Bridge. *Bottom*: The flood relief scheme led to major reconstruction along the Soar. This work included the making, enlargement or replacement of the weirs where the river course was separated from the navigation for the purpose of locks and water mills. Evans Weir was so named because of the mill that formerly stood in the foreground. *RCHS Transparency Collection 42091; Ray Shill.*

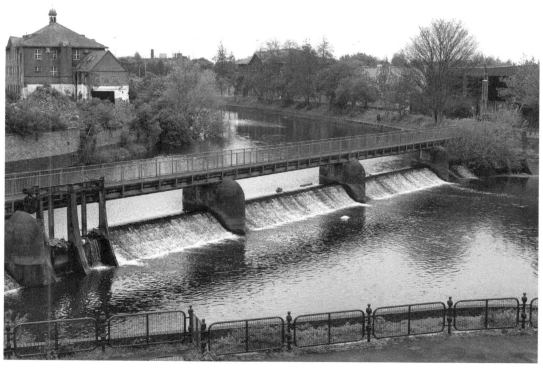

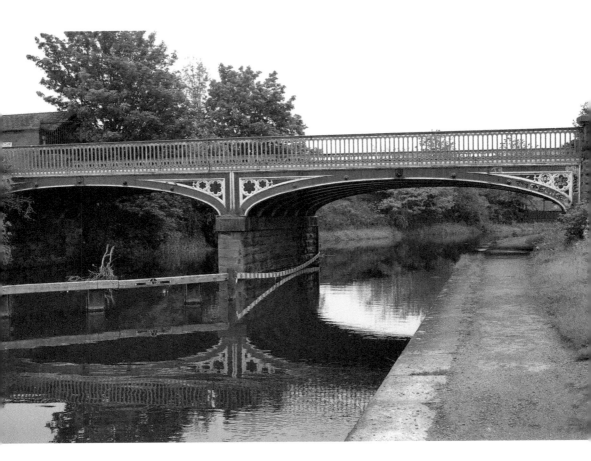

Leicester Navigation, Soar Lane Bridge

The decorative iron bridge over the Soar in Leicester was provided by the Midland Railway in 1879. This roadbridge was constructed parallel to a railway bridge (site in foreground) that carried the Leicester & Swannington branch line to Soar Lane Wharf. *Ray Shill.*

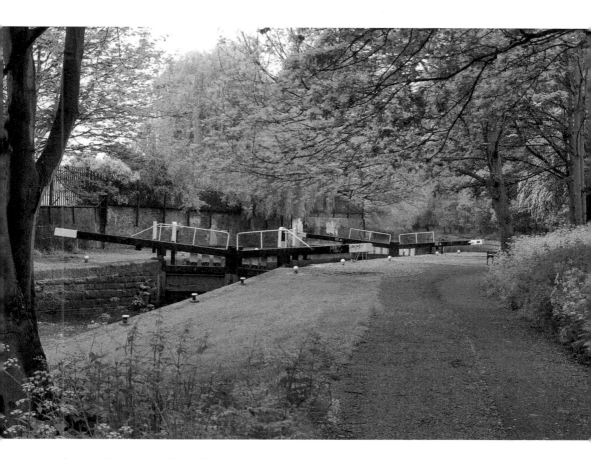

Leicester Navigation, Limekiln Lock

The now sylvan setting of Limekiln Lock hides a former industrial past; a bank of limekilns where where limestone was burned to produce lime on the far side of this lock. Limekiln Lock was constructed as a direct result of the flood relief scheme, when the bed of the Soar was deepened from this point to Belgrave Lock and at the same time a new canal channel cut. Whittaker Brothers were the contractors for this work, which was finished by October 1881. *Ray Shill.*

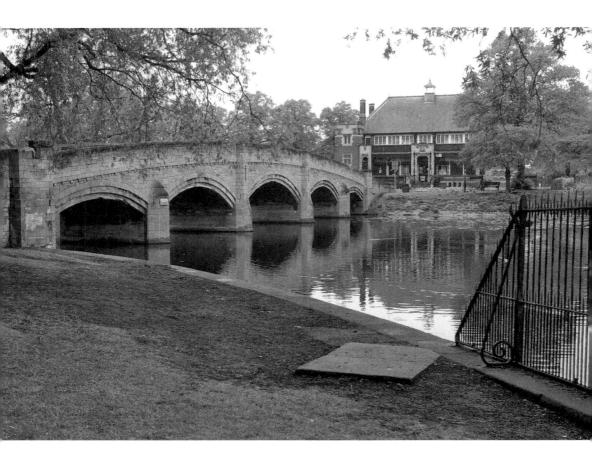

Leicester Navigation, 1881 Temporary Course, Abbey Park and Abbey Corner

While the Leicester Navigation was constructed as a canal from the Soar north of Belgrave Lock to North Lock, the decision to deepen the Soar as part of the flood relief scheme led to the building of Limekiln Lock and a diverted, but deeper, channel from Belgrave. The task of deepening and straightening the Soar had been given to Benton & Woodiwiss contractors, who constructed a new weir at Abbey Corner and a temporary lock for the use of craft while Limekiln Lock and the new cut were constructed. The arrangement remained in force until October 1881 when boats could revert to the original route. Work then went on laying out a new park, Abbey Park, around the river. The stone footbridge was a twentieth-century addition to this location. Eastwood & Swingler produced the ironwork for Abbey Park Roadbridge, which had previously been a bridleway. Benton & Woodiwiss built the supports in brick and stone. The temporary navigation had a towing path that followed the southern bank of the Soar from Belgrave Lock, crossed the Soar by a temporary bridge beside the permanent Abbey Park Bridge and then followed the land in the foreground to the temporary lock. Boats then passed up to the higher level and round to the Pasture Channel where another bridge was required for the barge horses to cross. *Ray Shill.*

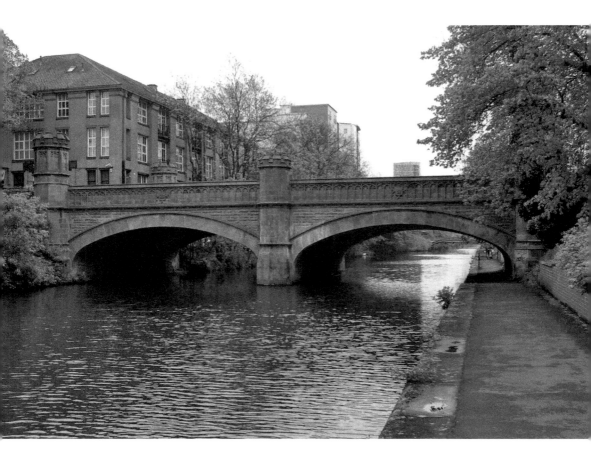

Leicestershire & Northamptonshire Canal, the Straight Mile
The flood relief programme made significant alterations to this section of the canal. Two locks and a mill stream were removed to make a straight course from Freeman's Meadow to the West Bridge. *Ray Shill.*

chapter seven

Twentieth-Century Navigations

Foxton Incline Plane, River Trent New Locks

Canals continued to change as the new century approached. Labour-saving devices were invented and electrical plant became more common. The Foxton Incline Plane came about following the granting of a patent of a new design, where the weight of the descending caisson was sufficient to draw up the other and the associated steam engine had only a compensatory role. While it was capable of carrying barges up to the summit level of the Old Union Canal, the fact that this waterway was only passable for narrowboats ultimately had a negative effect on trade. The lack of traffic shortened the working life of what was a canal engineering achievement.

Waterway promoters in the twentieth century drew inspiration from successful European ventures in Belgium, France, Germany and Holland. A new future for waterways, particularly river navigations, was envisaged even if few schemes were actually carried out.

One particular scheme that did receive support was the River Trent improvement (1921–27). The Trent improvement comprised new locks between Nottingham and Newark and a new port at Nottingham for Nottingham Corporation, who had taken over the section of the river between Nottingham and Newark, and with it the right to charge tolls. New river staithes and wharves were constructed alongside the bank at Colwick to cater for the trade in oil.

This was also a time of canal closures and abandonment, in particular of the railway-owned waterways. The London & North Eastern Railway obtained powers to abandon the Nottingham Canal between Lenton and the Cromford Canal as well as the whole length of the Grantham, maintaining this canal only as supply of water at the request of the Farmers' Union. Independent canal companies also closed pieces of their system. The Derby Canal, for example, ceased to use the branch to Little Eaton.

Ashby Canal, Moira, 1919
A 2-mile deviation of the Ashby Canal was constructed in 1919 to avoid a bad stretch of the existing canal, which had been damaged by mining subsidence. A special ceremony was held in August, at which a narrowboat cut the ribbon to mark the event. *RCHS Print Collection 40075.*

Opposite: Grand Junction Canal (Old Union Section), Foxton Incline Plane
The incline plane at Foxton (*top*) was the largest constructed in Britain and operated a pair of steel tanks. Each tank ran on eight sets of wheels along four sets of rails at a gradient of one in four. Each chamber measured 80 feet by 15 feet inside and was wide enough to hold a Trent Barge or two narrowboats breasted side by side. The docks were connected by 7-inch circumference wire ropes that passed round pulleys to the central haulage drum located in the winding house at the incline top. Construction began in 1898 and the completed lift opened on 10 July 1900. Regrettably the lift only functioned for a few years and Trent Boats were never able to pass the length of the Old Union Canal. The period of disuse was in fact longer than actual use, and in the majority of photographs it appears in the semi-derelict state seen below. In 1928 the lift was finally removed and the metal parts scrapped. *RCHS Transparency Collection 42054; RCHS Weaver Collection 46696.*

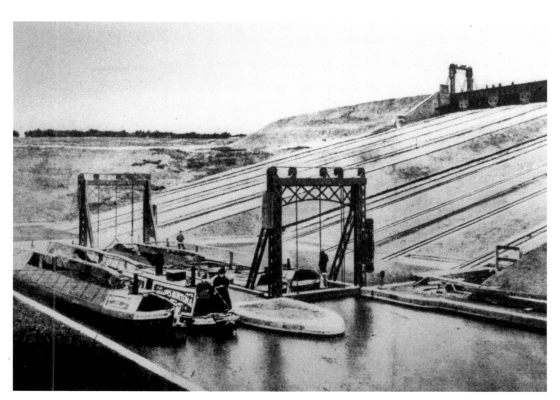

Grand Junction Canal, Foxton Locks, Gwynne Winding Engine

Foxton Incline Plane was built under the direction of John & Henry Gwynne of Hammersmith, engineers. The plant included both hydraulic and haulage parts. Hydraulics were used to lower and raise the boat gates fitted to each moveable tank or dock, and the two boat lift tanks were counterbalanced. These tanks were raised and lowered with the assistance of wire ropes drawn around pulleys and a large haulage drum. The descent of one raised the other, but to supplement the power lost through friction, a steam engine was employed to assist the process. The drive to the large haulage drum was in the form of an inverted, vertical compound steam engine that was probably supplied by John & Henry Gwynne. Engineering had progressed from the early days of pumping-engine manufacture and more efficient engines were now commonly produced. In compound engines the steam was used more than once by passing from one cylinder working at high pressure into others working at lower pressures. With the Foxton engine the process was doubled – that is, the steam passed from the high pressure cylinder to act on a low pressure cylinder, a process that added to the economy of the engine. This engine was fitted with a jet condenser that sprayed cold water into the exhaust steam, creating a vacuum, a facility that further increased the power of the engine. *RCHS Weaver Collection 46694.*

Lifts, canal. Barges or vessels are transferred from one level to another by wet docks A mounted on inclined rails B so as to be moved broadside on. Two docks may be connected by ropes or chains H so as to work simultaneously in opposite directions and balance each other, or a single dock may be balanced by a weight running on the same or another incline. The carriages are actuated by a winding-engine and ropes I, or by any other suitable means. The ends of the dock are closed by vertical sliding water-tight gates counterbalanced by weights and operated by worm or other gear. Gates F, F^1, at the head bay or pond, are provided with the usual valves, and are closed whenever the docks are moved. Projecting ribs a^2, a^3, at the bottom and rear side of the dock, bear against ribs d^2, d^3 of the framework or the gates F, F^1 when the dock is raised, in order to make a water-tight joint. The inclined ways may be arranged parallel to one another and in echelon as shown, or they may converge to one another.

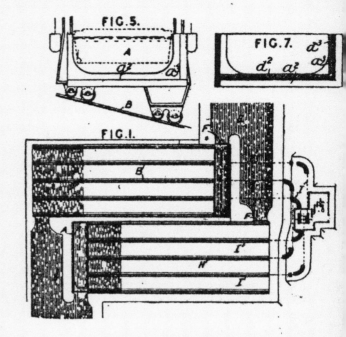

Patent Specification (Abstract), April 1896

81

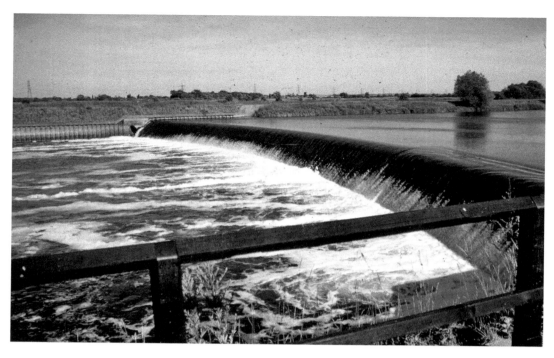

River Trent, Cromwell Lock Weir and Trent Navigation, Cromwell Lock

The Trent Navigation Company had a grand vision to improve the navigation between Nottingham and Cromwell with a group of new locks. The only one completed before 1914 was Cromwell Lock, north of Newark, which raised water levels between Cromwell and Newark. An extension was provided to this lock in 1935, and British Waterways subsequently merged the two chambers. *RCHS Transparency Collection 76301, 76302.*

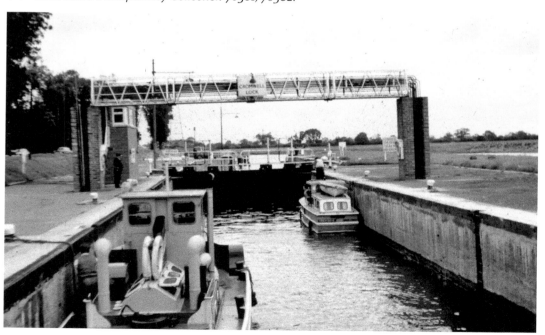

River Trent, Holme Locks & Lock House

The original lock as built for the Trent Navigation Company under the 1794 Act was on the left-hand side of the present lock chamber (*above right*). *Ray Shill.*

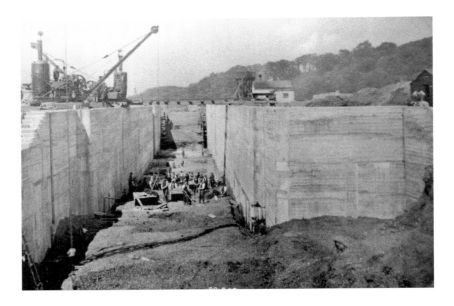

River Trent, Stoke Bardolph Lock and Gates

Despite the Trent Navigation Company intended improvement scheme, the onset of the First World War curtailed any further improvement. Nottingham Corporation decided to take over part of the scheme and with it the maintenance and operation of the River Trent between Nottingham and the south of Newark, replacing Holme Lock with a larger lock chamber and constructing three locks at Stoke Bardolph, Gunthorpe and Hazelford. Lock-gate construction was carried out in the lock chamber, with carpenters assembling each of the four gates (two upper and two lower gates) prior to fitting. An important part of making the lock ready for use was dredging the channels at both ends and forming the communications with the Trent Navigation. *Canal & River Trust Archives, Ellesmere Port.*

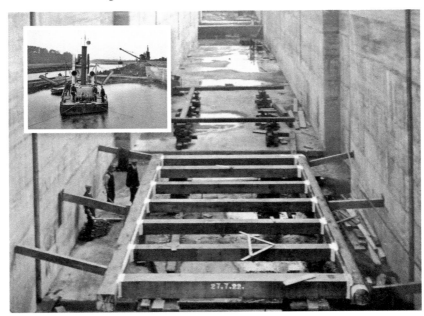

River Trent, Gunthorpe Lock and Weir, 2011

Two views of Gunthorpe Lock: that above shows the upstream entrance channel and the bottom view is a view of the downstream entrance and weir. Work started on the Gunthorpe and Hazelford Locks as Stoke Bardolph was approaching completion. Men employed on the work by Nottingham Corporation could still commute out by train to Gunthorpe and Hazelford, and barracks were provided at Hazelford for those who chose not to commute. *Ray Shill.*

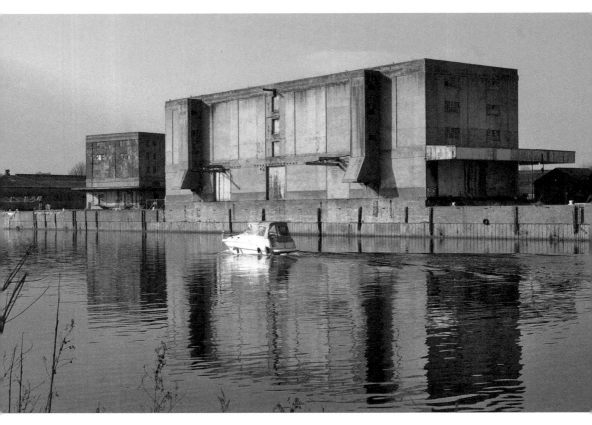

River Trent, Nottingham Corporation Warehouses, Trent Lane Wharf
The concrete warehouses beside the Trent were constructed for the Nottingham Corporation for the barge trade created with the new Trent locks. The wharves were built between 1925 and 1933, when a branch railway to Trent Wharf was made for the LMS Railway. Trent Lane Wharf passed to the Docks & Inland Waterways in 1948 and became the property of British Waterways from 1963. *Ray Shill.*

Nationalisation, Restoration and Trusts

Docks & Inland Waterways Executive, British Waterways (Canal Closure), Canal & River Trust

The creation of the Docks & Inland Waterways Executive (DIWE) was a result of the 1948 Transport Act. This Executive first took over many of the independent waterways and then set about merging these with the canals acquired by the Railway Executive, a task that was finally completed during 1950. Canals and river navigations that remained outside this arrangement were: Charnwood Forest Canal (derelict), Derby Canal, Nutbrook Canal, Oakham Canal (derelict), Stamford Navigation & Wreak Navigation (derelict). The Oakham had been acquired by a railway company and had its lines of communication severed. Much of what remained was disposed of to local people, even if parts remained in water.

Other railway-owned waterways were the Ashby, Chesterfield and Grantham Canals. The Nottingham above Lenton had been abandoned and parts were gradually filled in. The remainder passed to the Trent Navigation, which was acquired by the Docks & Inland Waterways Executive in 1948. The Grantham remained purely a water supply and the north part of the Ashby Canal was closed following serious mining subsidence.

Trade improvements undertaken by the nationalised waterway network included further work on the Trent. At Nottingham the old Holme Flood Lock was removed as the river channel was widened, and Holme Lock and Holme Sluices were instead constructed as part of a flood relief scheme. Other improvements included a new lock on the Soar near Redhill and the enlargement of the town lock at Newark (1952).

Under the 1954 Transport Act, British Waterways, successor to the DIWE, arranged for closure of several disused canals. This policy of closure continued, but there was a growing force of dedicated boaters keen to keep as much of remaining network open as possible. The declining commercial traffic came to be supplemented by the increasing pleasure boat trade. A few privately owned craft and hire boats had been present prior to this time, but there was now a larger and expanding number. There were also those people who wanted to give their free time to restoring old waterways. A growing band of supporters pressed on with other restorations across the country, mainly using volunteer labour and some other local support from time to time. Those East Midland canals to be the target of restoration work included parts of the Cromford and Grantham.

The Chesterfield Canal comprised both a working and disused waterway. With the 1968 Transport Act, part from Stockwith to Worksop was considered by Barbara Castle to be fit enough to be classified as a cruiseway, but the rest was designated a remainder waterway. This latter part comprised parts in water, parts disused and a closed tunnel. The Chesterfield Canal Society, formed in 1976, made a start on the gradual restoration, aided by considerable and in-depth research regarding the history of the undertaking by Christine Richardson. The fruits of their efforts, and that of the Chesterfield Waterways Partnership (from 1995), has led to the restoration of the canal and locks from Worksop to Kiveton (2003) and from Chesterfield to

Staveley. A feature of the Chesterfield Canal is that it has two summit levels. The route from Chesterfield to Staveley falls by five locks and reaches Staveley Basin, completed during 2012. It then follows a level section through Renishaw and climbs again to the summit at Norwood. The intermediate unrestored section of 8 miles requires considerable work, including a diversion to avoid houses built on the line of the canal at Killamarsh.

State owned waterways came under the jurisdiction of British Waterways, in 1963, following the abolishment of the British Transport Commission. They have continued to manage the network, but waterways in England and Wales passed to the Canal & River Trust in July 2012.

Not all waterways fall into this category. The Nene is owned by the Environment Agency and while there are future plans for integration, this is not anticipated until at least 2015.

No independent undertaking are presently open as navigations although there are long-term plans to restore the Derby Canal. A scheme to build a new canal to Daventry has been under consideration since 2006 and another new canal scheme has been proposed to link the Grand Union Canal (old Grand Junction) at Milton Keynes with the Great Ouse at Bedford.

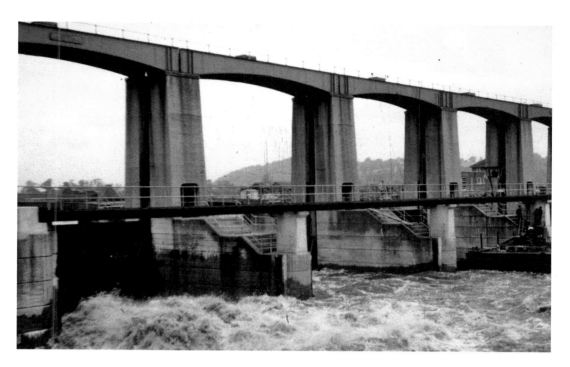

River Trent, Holme Sluices

The final improvement to navigation along the Trent at Nottingham was made with the reconstruction of Holme Lock Cut, which was accompanied by the diversion of the main river channel along a course parallel to Holme Locks and the removal of the original route and bend that turned north. This work was done as part of the Nottingham flood relief scheme. *RCHS Transparency Collection 76341; Ray Shill.*

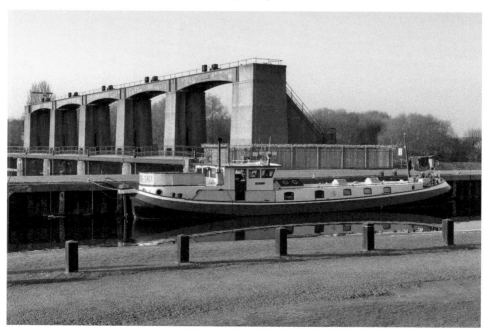

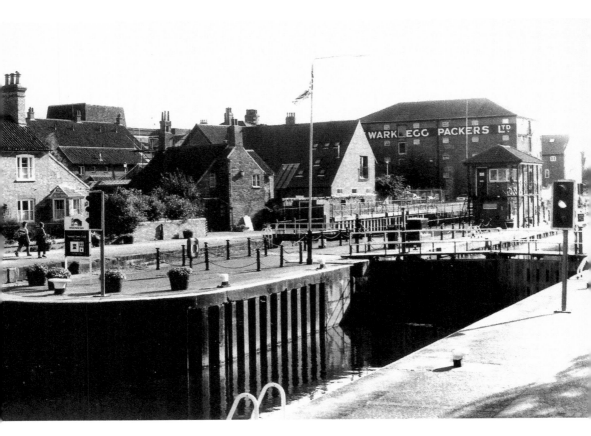

River Trent Navigation, Newark Town Lock
Newark Town lock was improved from time to time. The last reconstruction was made by British Waterways in 1952. *Ray Shill.*

Canal Bed, Renishaw, Chesterfield Canal, 2008
The Chesterfield Canal Partnership is proceeding with restoring parts of the canal between Staveley and Kiveton. Here earth-moving equipment had dug out part of the route intended to be restored. A feature of modern canal reconstruction is the extensive use of concrete. This applies at the new basin at Staveley as well as overbridges along the restoration route. Sadly even modern structures are not immune from graffiti. *Ray Shill.*

Daventry Canal – Vision of the Future or Forlorn Hope?
The first decade of the twenty-first century has produced a variety of new canal schemes. This artist's impression of canal terminus basins at Daventry was publicised during 2006. The plan then and now is to build a link waterway with the Grand Union Canal that will either require six locks or a boat lift. *Ray Shill.*

Restoration Schemes in the East Midlands

Chesterfield Canal Partnership
Only part of the Chesterfield Canal was granted cruiseway status, from Stockwith to Worksop, and the remainder of the waterway was restored initially by the Chesterfield Canal Society, formed in 1976, which became the Chesterfield Canal Trust in 1998. They instigated the restoration through to Norwood from Worksop and from Chesterfield to Staveley. The Chesterfield Canal Partnership was formed in 1995, and their task was to co-ordinate restoration efforts and complete the task started by the canal society. Their present ambition is simple: to restore the whole of the waterway to full public use. It became a joint venture between the Chesterfield Canal Trust, British Waterways, local councils, and heritage and nature groups. It is now involved in the restoration of the intermediate 8 miles between Staveley and Kiveton, which involves the making of new locks to Rother Valley Park (avoiding houses built on the bed of the canal at Killamarsh), a second flight of locks to return the navigation back to the original route, the restoration of Norwood Locks, and additional locks to a new summit over the top of Norwood Tunnel linking with a proposed marina site and to descend again to join up with the existing waterway at Norwood Tunnel East Portal. Other associated schemes involve making the River Rother navigable from Rotherham to Killamarsh and creating a new inland navigation link between the Chesterfield Canal and the South Yorkshire Navigation.

Daventry Canal Association
The aim is to build a navigation from the Grand Union Canal to Daventry, but the group faces opposition from the Friends of Daventry Open Spaces.

Derby Canal
While restoration of the Derby Canal has been contemplated for a number of years, it was only in 2012 that overall planning permission for the task was granted. Finance is now sought to commence restoration on the Swarkestone and Sandiacre routes. A novel feature of the present proposals is a caisson that will swing across the River Derwent and transfer craft from one side of the river to the other.

Grantham Restoration Partnership
This organisation was reformed in 2004 for restoration of the navigable link between Grantham and the Trent at Nottingham.

Melton & Oakham Waterways Society
Their aim is to first restore the Wreak Navigation and then investigate what work could be done to the Oakham Canal.

Notable Structures on Midland Navigable Waterways

Grid references for lock flights and tunnels West-to-East or North-to-South
Grid references for feeders reservoir dam to canal inflow

Ashby Canal
Marston Junction SP368882
Sence Aqueduct SK377066
Shenton Aqueduct SK392007
Snarestone Tunnel (N/S) SK392096–SK392094

Bond End Canal
Bond End Lock SK247224
Shobnall Lock SK234233

Chesterfield Canal
Barnby Fox Covert Lock SK666830
Drakeholes Tunnel SK707904
East Stockwith Basin & Junction SK786945
Gringley Top Lock SK727917
Harthill Reservoir Feeder (S/N) SK460806–
 SK506824
River Idle Aqueduct SK703805
Idle Tributary Aqueducts (2) SK703804, SK703806
Lady Lee Branch (W/E) SK566795
Norwood Staircase Locks 6–19 (W/E) SK469819–
 SK473819
Misterton Top Lock SK774946
Norwood Tunnel (W/E) SK475819–SK501825
River Ryton Aqueduct, Retford SK597790
River Ryton Aqueduct, Shireoaks SK549813
Roman Road Bridge, Clayworth SK723887
Retford Lock SK706806
Shireoaks Locks (3) SK557807
Thorp Locks 20–28 (W/E) SK523819–SK528514
Turnerwood Lock Flight 34–41 (W/E) SK533816–
 SK541813
Wiseton Bridge SK 718897
Worksop Warehouses SK585793

Cromford Canal
Bucklands Hollow Canal Bridge SK357524

Butterley Tunnel (W/E) SK394517–SK422513
Codnor Park Reservoir Dam SK435516
Cromford Wharf SK300570
Derwent Aqueduct (Leawood) SK313556
Gregory Tunnel SK327555
High Peak Aqueduct SK320555
High Peak Railway Wharf SK313560
Leawood Pumping Station SK315557
Pinxton Wharf SK453543

Derby Canal
Canal Bridge, Borrowash SK412347
Holmes Wharves SK357363
Little Eaton Basin SK363411
Shacklecross Lock SK421340
Swarkestone Junction SK372293
Swarkestone Locks to Trent (N/S) SK367290–
 SK368285

Derby Canal Tramways
Little Eaton Gangroad Tramway (N/S) SK364421–
 SK363411

Derwent Navigation
Borrowash Mill SK414342
Wilne Mill SK448315

Erewash Canal
Erewash Aqueduct, Shipley Gate SK462355
Sheet Stores & Canal Basin, Long Eaton SK488321
Trent Lock SK491312

Fossdyke
Catchwater Drain Aqueduct SK954720
Drinsey Nook SK877743
River Till Junction SK917749
Torksey Lock SK836781

Grantham Canal
Belvoir Tramway Wharf SK817359
Denton Reservoir Feeder (N/S) SK869342–
 SK871339
Denton Reservoir Dam SK871339
Grantham Basin SK909356
Polser Brook Aqueduct SK633365
Rundle Beck Aqueduct SK756325
Smite Aqueduct SK715295
Stroom Dyke Aqueduct SK738308
Thurlbeck Dyke Aqueduct SK626367
Trent Lock SK584386
Woolsthorpe Locks (W/E) SK853352–SK845350

Grand Union
Grand Junction Canal
Blisworth Tunnel SP729529–SP739503
Braunston Gauging House SP545660
Braunston Locks (W/E) SP545660–SP554656
Braunston Tunnel (W/E) SP557654–SP576652
Buckby Locks (N/S) SP605657–SP618643
Norton Junction SP603657
Weedon Aqueduct (Brook Street) SP633596
Weedon Aqueduct (Church Street, St Peters)
 SP634593
Grand Junction Canal (Northampton Branch)
Gayton Junction SP720550
Lock 17 SP754596
Weedon Ordnance Branch
Branch Canal SP624595–SP632596

Leawood Branch (Private)
Railway Aqueduct (site of) SK317557

Leicester Navigation
Abbeygate Weir (site of temporary lock) SK583058
Barrow on Soar Lock SK573173
Belgrave Lock (original site of) SK591068
Belgrave Lock (new) SK591067
Cossington Lock SK595128
Junction Lock SK603123
Limekiln Lock SK590057
Mountsorrel Lock SK583153
North Lock SK580052
Pilling's Lock SK566183
Thurmaston Lock SK606095
Leicester Navigation (Charnwood Forest Canal)
Blackbrook Reservoir Dam (W/E) SK457177–
 SK458178
Tunnel, near Shepshed SK459185

Leicester & Northampton Union Canal
Aylestone Lock SK577025
Debdale Wharf SP696916
Freeman's Meadow Lock SK580030
Great Glenn Aqueduct (River Sence) SK655959
Kilby Bridge Wharf SP609969
King's Lock SK567007
Market Harborough Basin SP728879
Saddington Reservoir Feeder SP663914–SP671923
Saddington Tunnel (W/E) SP658933–SP664927
Smeeton Aqueduct SK621922

Nottingham Canal
Butterley Reservoir Feeder SK394517
Castle Lock SK570393
Trent Lock SK582384

Nutbrook Canal
Paul's Arms Bridge SK445438
Stanhope Arm SK462394

Oakham Canal
Site of Crossing (Aqueduct over Eye), Saxby
 SK821193
Oakham Basin SK862093

Old Grand Union
Avon Aqueduct SP627824
Crick Wharf SP596726
Crick Tunnel SP595722–SP592706
Foxton Locks (N/S) SP692897–SP692895
Foxton Incline Plane SP693896
Husbands Bosworth Tunnel (W/E) SP632845–
 SP642848
Watford Locks (N/S) SP593688–SP594684
Welford Wharf SP646809

Oxford Canal
Braunston Wharf SP538657
River Leam Aqueduct SP530657
Old Leam Aqueduct SP533645

River Nene
Wansford Locks SP075983, SP076985

Soar Navigation & Loughborough Canal
Loughborough Wharf SK535199
Ratcliffe Lock SK492293
Redhill Lock SK492303
Zouch Lock SK510235

Trent & Mersey Canal (Main Line)
Derwent Mouth Junction (with Trent) SK458307
Dove Aqueduct SK268269
Shardlow Wharves (W/E) SK441303–SK44303
Trent Navigation (Alrewas–Wichnor) SJ172154–
 SJ185161

Trent Navigation
Averham Weir SK772537
Beeston Locks SK536354
Cromwell Lock SK808611
Cranfleet Cut, Occupation Bridge SK496313
Cranfleet Locks SK502316
Cranfleet Flood Lock SK493312
Gainsborough Bridge SK815891
Gainsborough Wharves SK813898
Gunthorpe Lock SK687437
Harrington Bridge SK471312
Hazelford Lock SK734495

Holme Locks SK615394
Newark Nether Lock SK802553
Newark Town Lock SK795538
Sawley Flood Lock SK471309
Sawley Locks SK478307
Stoke Bardolph Lock SK649407
Beeston Turnover Bridge SK541356

Upper Trent Navigation
Burton Forge Lock SK262240
Kings Mills SK415274
Swarkestone Bridge SK369285

Wreake & Eye Navigation
Eye Kettleby Lock SK738184
Frisby Lock SK698181
Hoby Bridge SK672169
Melton Mowbray Basin (site of) SK753188
Turnwater Meadow Junction SK608122